ART OBJECTS

ART
OBJECTS

Essays on Ecstasy and Effrontery

JEANETTE
WINTERSON

Alfred A. Knopf New York 1996

THIS IS A BORZOI BOOK
PUBLISHED BY ALFRED A. KNOPF, INC.

Library of Congress Cataloging-in-Publication Data

Winterson, Jeanette, [date]
Art objects : essays on ecstasy and
effrontery / Jeanette Winterson.
p. cm.
ISBN 0-679-44644-3
1. Winterson, Jeanette, [date]—Aesthetics. 2. Woolf,
Virginia, 1882–1941—Criticism and interpretation.
3. Women and literature. 4. Aesthetics, Modern.
I. Title.
PR6073.I558A8 1996
824'.914—dc20 95-33215
CIP

Manufactured in the United States of America
FIRST AMERICAN EDITION

for Peggy Reynolds with love

My thanks are due to Frances Coady
and the team at Jonathan Cape and
Vintage Books. To Massimo Rao,
Marianna Kennedy, Jim Howett,
and of course, Philippa Brewster.

If truth is that which lasts, then art has
proved truer than any other human endeavour.
What is certain is that pictures and poetry
and music are not only marks in time but marks
through time, of their own time and ours, not
antique or historical, but living as they ever
did, exuberantly, untired.

CONTENTS

PART ONE

ART OBJECTS

ART OBJECTS

I was in Amsterdam one snowy Christmas when the weather had turned the canals into oblongs of ice. I was wandering happy, alone, playing the *flâneur*, when I passed a little gallery and in the moment of passing saw a painting that had more power to stop me than I had power to walk on.

The quality of the draughtsmanship, the brush strokes in thin oils, had a Renaissance beauty, but the fearful and compelling thing about the picture was its modernity. Here was a figure without a context, in its own context, a haunted woman in blue robes pulling a huge moon face through a subterranean waterway.

What was I to do, standing hesitant, my heart flooded away?

I fled across the road and into a bookshop. There I would be safe, surrounded by things I understood, unchallenged, except by my own discipline. Books I know, endlessly, intimately. Their power over me is profound, but I do know them. I confess that until that day I had not much

interest in the visual arts, although I realise now, that my lack of interest was the result of the kind of ignorance I despair of in others. I knew nothing about painting and so I got very little from it. I had never given a picture my full attention even for one hour.

What was I to do?

I had intended to leave Amsterdam the next day. I changed my plans, and sleeping fitfully, rising early, queued to get into the Rijksmuseum, into the Van Gogh Museum, spending every afternoon at any private galleries I could find, and every evening, reading, reading, reading. My turmoil of mind was such that I could only find a kind of peace by attempting to determine the size of the problem. My problem. The paintings were perfectly at ease. I had fallen in love and I had no language. I was dog-dumb. The usual response of 'This painting has nothing to say to me' had become 'I have nothing to say to this painting'. And I desperately wanted to speak.

Long looking at paintings is equivalent to being dropped into a foreign city, where gradually, out of desire and despair, a few key words, then a little syntax make a clearing in the silence. Art, all art, not just painting, is a foreign city, and we deceive ourselves when we think it familiar. No-one is surprised to find that a foreign city follows its own customs and speaks its own language. Only a boor would ignore both and blame his defaulting on the place. Every day this happens to the artist and the art.

We have to recognise that the language of art, all art, is not our mother-tongue.

I read Ruskin's *Modern Painters*. I read Pater's *Studies of the History of the Renaissance*. Joshua Reynolds' *Discourses*, Bernard Berenson, Kenneth Clark, Sickert's *A Free House!*, Whistler's *Ten O'Clock Lecture*, Vasari, Michael Levey, William Morris. I knew my Dante, and I was looking for a guide, for someone astute and erudite with whom I had something in common, a way of thinking. A person dead or alive with whom I could talk things over. I needed someone I could trust, who would negotiate with me the sublimities and cesspits of regions hitherto closed. Someone fluent in this strange language and its dialects, who had spent many years in that foreign city and who might introduce me to the locals and their rather odd habits. Art is odd, and the common method of trying to fit it into the scheme of things, either by taming it or baiting it, cannot succeed. Who at the zoo has any sense of the lion?

At last, back home, and ransacking the shelves of second-hand bookshops, I found Roger Fry.

It may seem hopelessly old-fashioned to have returned to Bloomsbury, but I do not care about fashion, only about permanencies, and if books, music and pictures are happy enough to be indifferent to time, then so am I.

Fry was the one I wanted. For me, at least, a perfect guide, close enough in spirit to Walter Pater, but necessarily firmer. I had better come clean now and say that I do not believe that art (all art) and beauty are ever separate, nor do I believe that either art or beauty are optional in a sane society. That puts me on the side of what Harold Bloom calls 'the ecstasy

5

of the privileged moment'. Art, all art, as insight, as rapture, as transformation, as joy. Unlike Harold Bloom, I really believe that human beings can be taught to love what they do not love already and that the privileged moment exists for all of us, if we let it. Letting art is the paradox of active surrender. I have to work for art if I want art to work on me.

I knew about Roger Fry because I had read Virginia Woolf's biography of him, and because it is impossible to be interested in Modernism without finding reference to him. It was he who gave us the term 'Post-Impressionist', without realising that the late twentieth century would soon be entirely fenced in with posts.

A Quaker, trained as a scientist, passionate about painting, Roger Fry did more than anyone else in Britain to promote and protect new work during the first thirty years of the century. The key quality in Fry's writing is enthusiasm. Nothing to him is dull. Such a life-delighting, art-delighting approach, unashamed of emotion, unashamed of beauty, was what I needed.

I decided that my self-imposed studentship would perform a figure of eight. I would concentrate my reading on priests and prophets of the past, while focusing my looking on modern painters. This saved me from the Old Master syndrome and it allowed me to approach a painting without unfelt reverence or unfit complacency. At the same time it allowed me to test out the theories and assumptions of the art writers whose company I kept. For me, this lemniscate of back and forth has proved the right method. I still know far far less about pictures than I do about books and this will not change. What has changed is my way of

seeing. I am learning how to look at pictures. What has changed is my capacity of feeling. Art opens the heart.

Art takes time. To spend an hour looking at a painting is difficult. The public gallery experience is one that encourages art at a trot. There are the paintings, the marvellous speaking works, definite, independent, each with a Self it would be impossible to ignore, if . . . if . . . , it were possible to see it. I do not only mean the crowds and the guards and the low lights and the ropes, which make me think of freak shows, I mean the thick curtain of irrelevancies that screens the painting from the viewer. Increasingly, galleries have a habit of saying when they acquired a painting and how much it cost . . .

Millions! The viewer does not see the colours on the canvas, he sees the colour of the money.

Is the painting famous? Yes! Think of all the people who have carefully spared one minute of their lives to stand in front of it.

Is the painting Authority? Does the guide-book tell us that it is part of The Canon? If Yes, then half of the viewers will admire it on principle, while the other half will dismiss it on principle.

Who painted it? What do we know about his/her sexual practices and have we seen anything about them on the television? If not, the museum will likely have a video full of schoolboy facts and tabloid gossip.

Where is the tea-room/toilet/gift shop?

Where is the painting in any of this?

Experiencing paintings as moving pictures, out of context, disconnected, jostled, over-literary, with their endless accompanying explanations, over-crowded, one against the other, room on room, does not make it easy to fall in love. Love takes time. It may be that if you have as much difficulty with museums as I do, that the only way into the strange life of pictures is to expose yourself to as much contemporary art as you can until you find something, anything, that you will go back and back to see again, and even make great sacrifices to buy. Inevitably, if you start to love pictures, you will start to buy pictures. The time, like the money, can be found, and those who call the whole business élitist, might be fair enough to reckon up the time they spend in front of the television, at the DIY store, and how much the latest satellite equipment and new PC has cost.

For myself, now that paintings matter, public galleries are much less dispiriting. I have learned to ignore everything about them, except for the one or two pieces with whom I have come to spend the afternoon.

Supposing we made a pact with a painting and agreed to sit down and look at it, on our own, with no distractions, for one hour. The painting should be an original, not a reproduction, and we should start with the advantage of liking it, even if only a little. What would we find?

Increasing discomfort. When was the last time you looked at anything, solely, and concentratedly, and for its own sake? Ordinary life passes in a near blur. If we go to the theatre or the cinema, the images before us change constantly, and there is the distraction of language. Our loved ones are so well known to us that there is no need to look at them, and one of the gentle jokes of married life is that we do not. Nevertheless, here is a painting and we have agreed to look at it for one hour. We find we are not very good at looking.

Increasing distraction. Is my mind wandering to the day's work, to the football match, to what's for dinner, to sex, to whatever it is that will give me something to do other than to look at the painting?

Increasing invention. After some time spent daydreaming, the guilty or the dutiful might wrench back their attention to the picture.

What is it about? Is it a landscape? Is it figurative? More promisingly, is it a nude? If the picture seems to offer an escape route then this is the moment to take it. I can make up stories about the characters on the canvas much as art-historians like to identify the people in Rembrandt's *The Night Watch*. Now I am beginning to feel much more confident because I am truly engaging with the picture. A picture is its subject matter isn't it? Oh dear, mine's an abstract. Never mind, would that pink suit me?

Increasing irritation. Why doesn't the picture *do* something? Why is it hanging there staring at me? What is this picture

for? Pictures should give pleasure but this picture is making me very cross. Why should I admire it? Quite clearly it doesn't admire me . . .

Admire me is the sub-text of so much of our looking; the demand put on art that it should reflect the reality of the viewer. The true painting, in its stubborn independence, cannot do this, except coincidentally. Its reality is imaginative not mundane.

When the thick curtain of protection is taken away; protection of prejudice, protection of authority, protection of trivia, even the most familiar of paintings can begin to work its power. There are very few people who could manage an hour alone with the *Mona Lisa*.

But our poor art-lover in his aesthetic laboratory has not succeeded in freeing himself from the protection of assumption. What he has found is that the painting objects to his lack of concentration; his failure to meet intensity with intensity. He still has not discovered anything about the painting but the painting has discovered a lot about him. He is inadequate and the painting has told him so.

It is not as hopeless as it seems. If I can be persuaded to make the experiment again (and again and again), something very different might occur after the first shock of finding out that I do not know how to look at pictures, let alone how to like them.

A favourite writer of mine, an American, an animal trainer, a Yale philosopher, Vicki Hearne, has written of the acute

awkwardness and embarrassment of those who work with magnificent animals, and find themselves at a moment of reckoning, summed up in those deep and difficult eyes. Art has deep and difficult eyes and for many the gaze is too insistent. Better to pretend that art is dumb, or at least has nothing to say that makes sense to us. If art, all art, is concerned with truth, then a society in denial will not find much use for it.

In the West, we avoid painful encounters with art by trivialising it, or by familiarising it. Our present obsession with the past has the double advantage of making new work seem raw and rough compared to the cosy patina of tradition, whilst refusing tradition its vital connection to what is happening now. By making islands of separation out of the unbreakable chain of human creativity, we are able to set up false comparisons, false expectations, all the while lamenting that the music, poetry, painting, prose, perform-ance art of Now, fails to live up to the art of Then, which is why, we say, it does not affect us. In fact, we are no more moved by a past we are busy inventing, than by a present we are busy denying. If you love a Cézanne, you can love a Hockney, can love a Boyd, can love a Rao. *If* you love a Cézanne rather than lip-service it.

We are an odd people: We make it as difficult as possible for our artists to work honestly while they are alive; either we refuse them money or we ruin them with money; either we flatter them with unhelpful praise or wound them with unhelpful blame, and when they are too old, or too dead, or

too beyond dispute to hinder any more, we canonise them, so that what was wild is tamed, what was objecting, becomes Authority. Canonising pictures is one way of killing them. When the sense of familiarity becomes too great, history, popularity, association, all crowd in between the viewer and the picture and block it out. Not only pictures suffer like this, all the arts suffer like this.

That is one reason why the calling of the artist, in any medium, is to make it new. I do not mean that in new work the past is repudiated; quite the opposite, the past is reclaimed. It is not lost to authority, it is not absorbed at a level of familiarity. It is re-stated and re-instated in its original vigour. Leonardo is present in Cézanne, Michelangelo flows through Picasso and on into Hockney. This is not ancestor worship, it is the lineage of art. It is not so much influence as it is connection.

I do not want to argue here about great artists, I want to concentrate on true artists, major or minor, who are connected to the past and who themselves make a connection to the future. The true artist is connected. The true artist studies the past, not as a copyist or a pasticheur will study the past, those people are interested only in the final product, the art object, signed sealed and delivered to a public drugged on reproduction. The true artist is interested in the art object as an art process, the thing in being, the being of the thing, the struggle, the excitement, the energy, that have found expression in a particular way. The true artist is after the problem. The false artist wants it solved (by somebody else).

If the true artist is connected, then he or she has much to give us because it is connection that we seek. Connection to the past, to one another, to the physical world, still compelling, in spite of the ravages of technology. A picture, a book, a piece of music, can remind me of feelings, thinkings, I did not even know I had forgot. Whether art tunnels deep under consciousness or whether it causes out of its own invention, reciprocal inventions that we then call memory, I do not know. I do know that the process of art is a series of jolts, or perhaps I mean volts, for art is an extraordinarily faithful transmitter. Our job is to keep our receiving equipment in good working order.

How?

It is impossible to legislate taste, and if it were possible, it would be repugnant. There are no Commandments in art and no easy axioms for art appreciation. 'Do I like this?' is the question anyone should ask themselves at the moment of confrontation with the picture. But if 'yes', why 'yes'? and if 'no', why 'no'? The obvious direct emotional response is never simple, and ninety-nine times out of a hundred, the 'yes' or 'no' has nothing at all to do with the picture in its own right.

'I don't understand this poem'
'I never listen to classical music'
'I don't like this picture'

are common enough statements but not ones that tell us anything about books, painting, or music. They are statements that tell us something about the speaker. That

should be obvious, but in fact, such statements are offered as criticisms of art, as evidence against, not least because the ignorant, the lazy, or the plain confused are not likely to want to admit themselves as such. We hear a lot about the arrogance of the artist but nothing about the arrogance of the audience. The audience, who have not done the work, who have not taken any risks, whose life and livelihood are not bound up at every moment with what they are making, who have given no thought to the medium or the method, will glance up, flick through, chatter over the opening chords, then snap their fingers and walk away like some monstrous Roman tyrant. This is not arrogance; of course they can absorb in a few moments, and without any effort, the sum of the artist and the art.

If the obvious direct emotional response is to have any meaning, the question 'Do I like this?' will have to be the opening question and not the final judgement. An examination of our own feelings will have to give way to an examination of the piece of work. This is fair to the work and it will help to clarify the nature of our own feelings; to reveal prejudice, opinion, anxiety, even the mood of the day. It is right to trust our feelings but right to test them too. If they are what we say they are, they will stand the test, if not, we will at least be less insincere. But here we come back to the first hurdle of art, and it is a high one; it shows us up.

When you say 'This work has nothing to do with me'. When you say 'This work is boring/pointless/silly/obscure/élitist etc.', you might be right, because you are looking at a fad, or you might be wrong because the work falls so outside of the safety of your own experience that in

order to keep your own world intact, you must deny the other world of the painting. This denial of imaginative experience happens at a deeper level than our affirmation of our daily world. Every day, in countless ways, you and I convince ourselves about ourselves. True art, when it happens to us, challenges the 'I' that we are.

A love-parallel would be just; falling in love challenges the reality to which we lay claim, part of the pleasure of love and part of its terror, is the world turned upside down. We want and we don't want, the cutting edge, the upset, the new views. Mostly we work hard at taming our emotional environment just as we work hard at taming our aesthetic environment. We already have tamed our physical environment. And are we happy with all this tameness? Are you?

Art cannot be tamed, although our responses to it can be, and in relation to The Canon, our responses are conditioned from the moment we start school. The freshness which the everyday regular man or woman pride themselves upon; the untaught 'I know what I like' approach, now encouraged by the media, is neither fresh nor untaught. It is the half-baked sterility of the classroom washed down with liberal doses of popular culture.

The media ransacks the arts, in its images, in its adverts, in its copy, in its jingles, in its little tunes and journalist's jargon, it continually offers up faint shadows of the form and invention of real music, real paintings, real words. All of us are subject to this bombardment, which both deadens our

sensibilities and makes us fear what is not instant, approach-
able, consumable. The solid presence of art demands from us
significant effort, an effort anathema to popular culture.
Effort of time, effort of money, effort of study, effort of
humility, effort of imagination have each been packed by
the artist into the art. Is it so unreasonable to expect a
percentage of that from us in return? I worry that to ask for
effort is to imply élitism, and the charge against art, that it is
élitist, is too often the accuser's defence against his or her
own bafflement. It is quite close to the remark 'Why can't
they all speak English?', which may be why élitist is the
favourite insult of the British and the Americans.

But, you may say, how can I know what is good and what is
not good? I may wince at the cheap seascape over the
mantelpiece but does that necessarily mean I should go to
the Tate Gallery and worship a floor full of dyed rice?

Years ago, when I was living very briefly with a
stockbroker who had a good cellar, I asked him how I could
learn about wine.

'Drink it' he said.

It is true. The only way to develop a palate is to develop a
palate. That is why, when I wanted to know about
paintings, I set out to look at as many as I could, using always,
tested standards, but continuing to test them. You can like a
thing out of ignorance, and it is perhaps a blessing that such
naiveté stays with us until we die. Even now, we are not as

closed and muffled as art-pessimists think we are, we do still fall in love at first sight. All well and good, but the fashion for dismissing a thing out of ignorance is vicious. In fact, it is not essential to like a thing in order to recognise its worth, but to reach that point of self-awareness and sophistication takes years of perseverance.

For most of us the question 'Do I like this?' will always be the formative question. Vital then, that we widen the 'I' that we are as much as we can. Vital then, we recognise that the question 'Do I like this?' involves an independent object, as well as our own subjectivity.

I am sure that if as a society we took art seriously, not as mere decoration or entertainment, but as a living spirit, we should very soon learn what is art and what is not art. The American poet Muriel Rukeyser has said:

> There is art and there is non-art; they are two universes (in the algebraic sense) which are exclusive . . . It seems to me that to call an achieved work 'good art' and an unachieved work 'bad art', is like calling one colour 'good red' and another 'bad red' when the second one is green.

If we accept this, it does not follow that we should found an Academy of Good Taste or throw out all our pet water-colours, student posters or family portraits. Let them be but know what they are, and perhaps more importantly, what they are not. If we sharpened our sensibilities, it is not that we would all agree on everything, or that we would suddenly feel the same things in front of the same pictures (or when reading the same book), but rather that our debates

and deliberations would come out of genuine aesthetic considerations and not politics, prejudice and fashion . . . And our hearts? Art is aerobic.

It is shocking too. The most conservative and least interested person will probably tell you that he or she likes Constable. But would our stalwart have liked Constable in 1824 when he exhibited at the Paris Salon and caused a riot? We forget that every true shock in art, whether books, paintings or music, eventually becomes a commonplace, even a standard, to later generations. It is not that those works are tired out and have nothing more to offer, it is that their discoveries are gradually diluted by lesser artists who can only copy but do know how to make a thing accessible and desirable. At last, what was new becomes so well known that we cannot separate it from its cultural associations and time-honoured values. To the average eye, now, Constable is a pretty landscape painter, not a revolutionary who daubed bright colour against bright colour ungraded by chiaroscuro. We have had a hundred and fifty years to get used to the man who turned his back on the studio picture, took his easel outdoors and painted in a rapture of light. It is easy to copy Constable. It was not easy to be Constable.

I cannot afford a Constable, or a Picasso, or a Leonardo, but to profess a love of painting and not to have anything original is as peculiar as a booklover with nothing on her shelves. I do not know why the crowds and crowds of visitors to public galleries do not go out and support new work. Are we talking love-affair or peep-show?

I move gingerly around the paintings I own because I know they are looking at me as closely as I am looking at them. There is a constant exchange of emotion between us, between the three of us; the artist I need never meet, the painting in its own right, and me, the one who loves it and can no longer live independent of it. The triangle of exchange alters, is fluid, is subtle, is profound and is one of those unverifiable facts that anyone who cares for painting soon discovers. The picture on my wall, art object and art process, is a living line of movement, a wave of colour that repercusses in my body, colouring it, colouring the new present, the future, and even the past, which cannot now be considered outside of the light of the painting. I think of something I did, the picture catches me, adds to the thought, changes the meaning of thought and past. The totality of the picture comments on the totality of what I am. The greater the picture the more complete this process is.

Process, the energy in being, the refusal of finality, which is not the same thing as the refusal of completeness, sets art, all art, apart from the end-stop world that is always calling 'Time Please!'.

We know that the universe is infinite, expanding and strangely complete, that it lacks nothing we need, but in spite of that knowledge, the tragic paradigm of human life is lack, loss, finality, a primitive doomsaying that has not been repealed by technology or medical science. The arts stand in the way of this doomsaying. Art objects. The nouns become an active force not a collector's item. Art objects.

The cave wall paintings at Lascaux, the Sistine Chapel ceiling, the huge truth of a Picasso, the quieter truth of

Vanessa Bell, are part of the art that objects to the lie against life, against the spirit, that it is pointless and mean. The message coloured through time is not lack, but abundance. Not silence but many voices. Art, all art, is the communication cord that cannot be snapped by indifference or disaster. Against the daily death it does not die.

All painting is cave painting; painting on the low dark walls of you and me, intimations of grandeur. The painted church is the tattooed body of Christ, not bound into religion, but unbound out of love. Love, the eloquent shorthand that volumes out those necessary invisibles of faith and optimism, humour and generosity, sublimity of mankind made visible through art.

Naked I came into the world, but brush strokes cover me, language raises me, music rhythms me. Art is my rod and staff, my resting place and shield, and not mine only, for art leaves nobody out. Even those from whom art has been stolen away by tyranny, by poverty, begin to make it again. If the arts did not exist, at every moment, someone would begin to create them, in song, out of dust and mud, and although the artifacts might be destroyed, the energy that creates them is not destroyed. If, in the comfortable West, we have chosen to treat such energies with scepticism and contempt, then so much the worse for us. Art is not a little bit of evolution that late-twentieth-century city dwellers can safely do without. Strictly, art does not belong to our evolutionary pattern at all. It has no biological necessity. Time taken up with it was time lost to hunting, gathering,

mating, exploring, building, surviving, thriving. Odd then, that when routine physical threats to ourselves and our kind are no longer a reality, we say we have no time for art.

If we say that art, all art is no longer relevant to our lives, then we might at least risk the question 'What has happened to our lives?' The usual question, 'What has happened to art?' is too easy an escape route.

I did not escape. At an Amsterdam gallery I sat down and wept.
When I sold a book I bought a Massimo Rao. Since that day I have been filling my walls with new light.

PART TWO

TRANSFORMATION

WRITER, READER, WORDS

The writer is an instrument of transformation.

To begin with the reader. The ordinary reader is not primarily concerned with questions of structure and style. He or she decides on a book, enjoys it or doesn't, finishes it or doesn't, and is, perhaps affected by it. When the fiction or the poem has a powerful effect likely to be lasting, the reader feels personally attached to both the work and the writer. Everyone has their favourite books to be read and re-read. Such things become talismans and love-tokens, even personality indicators, the truly bookish will mate on the strength of a spine. The moderately bookish may be more cautious about splicing together their literary and lubricious endeavours but the passion they feel for certain printed sheets will be as lively as any got between plain. The world of the book is a total world and in a total world we fall in love.

Falling for a book is not the nymph Echo falling for the sound of her own voice nor is it the boy Narcissus falling for

his own reflection. Those Greek myths warn us of the dangers of recognising no reality but our own. Art is a way into other realities, other personalities. When I let myself be affected by a book, I let into myself new customs and new desires. The book does not reproduce me, it re-defines me, pushes at my boundaries, shatters the palings that guard my heart. Strong texts work along the borders of our minds and alter what already exists. They could not do this if they merely reflected what already exists. Of course, strong texts tend to become so familiar, even to people who have never read them, that they become part of what exists, at least a distort of them does. It is very strange to read something supposedly familiar, The Gospels, *Great Expectations*, *Jane Eyre*, and to find that it is quite unlike our mental version of it. Without exception, the original will be as unsettling, as edgy as it ever was, we have learned a little and sentimental-ised the rest. The critic Christopher Ricks, in his essay on the Victorian thinkers, Arnold and Pater, points out how often people misquote their favourite texts; the misquote subtly shifting the meaning to one which better reflects the reality of the speaker. On a national level we do this all the time, co-opting works that win favour with our way of life, rejecting those that don't. Books that will neither co-operate nor disappear sooner or later get the Modern Classic treatment, in a bid to familiarise them at the level of challenge.

I do not mean to say that any of this is conscious; mostly it is not, and therein lies a difficulty. Art is conscious and its effect on its audience is to stimulate consciousness. This is sexy, this is exciting, it is also tiring, and even those who

welcome art-excitement have an ordinary human longing for sleep. Nothing wrong with that but we cannot use the book as a pillow. The comfort and the rest to be got out of art is not of the passive forgetting kind, it is inner quiet of a high order, and it follows the intensity, the excitement we feel when exposed to something new. Or does it? Only it seems if we are prepared to stay the course, not give up and doze off, not leap from rock to rock after new thrills. Books need to be deeply read as well as widely read which is one reason why it is wise never to trust a paid hack.

Our unconscious attitude to art is complex. We want it and we don't want it, often simultaneously, and at the same time as a book is working intravenously we are working to immunise ourselves against it. Our best antidote to art as a powerful force independently affecting us is to say that it is only the image of ourselves that is affecting us. The doctrine of Realism saves us from a bad attack of Otherness and it is a doctrine that has been bolstered by the late-twentieth-century vogue for literary biography; tying in the writer's life with the writer's work so that the work becomes a diary; small, private, explainable and explained away, much as Freud tried to explain art away.

It seems to me that the intersection between a writer's life and a writer's work is irrelevant to the reader. The reader is not being offered a chunk of the writer or a direct insight into the writer's mind, the reader is being offered a separate reality. A reality separate from the actual world of the reader, and just as importantly, separate from the actual world of the

writer. The question put to the writer 'How much of this is based on your own experience?' is meaningless. All or nothing may be the answer. The fiction, the poem, is not a version of the facts, it is an entirely different way of seeing. When we talk about the artist's vision we pay lip service to this other way of seeing but we are not very comfortable with it. If it exists, which we doubt, it is some kind of trick and nobody likes to be tricked. If it doesn't exist then we need not worry about responding to it. We can respond to the lifelikeness of the piece.

It was the Victorians who introduced an entirely new criterion into their study of the arts; to what extent does the work correspond to actual life? This revolution in taste should not be underestimated and although it began to stir itself before Victoria acceded the throne in 1837, Realism (not the Greek theory of Mimesis) is an idea that belongs with her as surely as the fantasy of Empire. To fix the date is difficult but I do not think it far fetched to say that the gap between the death of the last Romantic (Byron) in 1824 and the heyday of Oscar Wilde in the 1890s, is the gap where Realism, as we understand it, was birthed and matured.

It is instructive to look at how dress codes alter between, say, 1825 and 1845. The eighteenth-century dandy is out, the sober Victorian so beloved of costume drama, is in. No more embroidered waistcoats, lurid colours, topiary wigs, dashing cravats, pan-stick faces and ridiculous buckles and heels. For men, the change is immense and as men are stripped of all their finery, women are loaded down with theirs. There is a marked polarisation of the sexes, and whereas Byron could cheerfully wear jewels and make-up

without compromising his masculinity any man who tried to do so throughout the sixty glorious years might pay for his display with his liberty. The new foppishness of Oscar Wilde and the Decadents in the 1890s was as much a strike back into what had been allowed to men, as a move forward into what might be. As the eighteenth century disappeared (and centuries take a while to disappear) it took with it, play, pose and experiment. And I am not only thinking about dress. Can anyone imagine *Tristram Shandy* as a nineteenth-century novel?

The reaction against Romanticism was a very serious one, and if the Romantics were emotional, introspective, visionary and very conscious of themselves as artists, then the move against them and their work was bound to be in opposition; to be rational, extrovert, didactic, the writer as social worker or sage. The novels of the 1860s, the novel form we still assume to be the perfect, perhaps even the only model, were at that time a strange hybrid of the loose epic poem and the pamphlet. It was not the inheritor of the play, pose and experiment of Smollett and Sterne. The dreary list of Braddon, Oliphant, Trollope, Wood, need not bother us here, although I think that the eagerness with which the sentimental and the sensational was mopped up by novel readers, was in itself a backlash against the intensity demanded by the Romantic vision. Even Byron at his most rollicking and least controlled is an *intense* poet. Intensity was not a Victorian virtue. Or was it?

It was women poets who benefited from the collapse of the Romantic sensibility. Whilst the male poet suddenly found himself at odds with his poetic tradition; he should

not be dreamy, contemplative, a little mystical, a little delicate, a woman had no such struggle. If the sensibility of the Romantics looked 'unmasculine' to a fast developing action culture, it could certainly be feminine. We think about women novelists as being a nineteenth-century product but the rise and the popularity of the woman poet is just as extraordinary. The woman poet, unlike the majority of the women novelists, accepted her mantle of Otherness gracefully. She would lead the mind to higher things. She would redirect material energies towards emotional and spiritual contemplation. LEL (Letitia Elizabeth Landon), Felicia Hemans, Christina Rossetti, Elizabeth Barrett Browning, each accepted the distinction of the poet as poet. The particular struggle of Tennyson, how to be sensitive in an age that disliked sensitivity *in men*, was clearly not a problem for a woman. I do not want to suggest that women writers, and in particular women poets, found themselves in a blessed century, but I do think that the perceived alliance between the qualities peculiar to poetry and the qualities peculiar to women gave women a freedom to work their own form within the authority of tradition. It was this freedom, I think, which cleared the ground for the significant contribution of women to Modernism. Like Romanticism, Modernism was a poet's revolution, the virtues of a poetic sensibility are uppermost (imagination, invention, density of language, wit, intensity, great delicacy) and what returns is play, pose and experiment. What departs is Realism.

That should be unsurprising. Realism is not a Movement or a Revolution, in its original incarnation it was a

response to a movement, and as a response it was essentially anti-art. The mainspring of tension in the best Victorian writers is not religious or sexual, it is between the dead weight of an exaggeratedly masculine culture valuing experience over imagination and action above contemplation and the strange authority of the English poetic tradition. Who should the poet serve? Society or the Muse? This was a brand new question and not a happy one.

If the woman poet could avoid it, the male poet and the prose writers of either sex could not. Of the great writers, Emily Brontë chose well. Charlotte Brontë and George Eliot continually equivocate and the equivocation helps to explain the uneven power of their work. Dickens is to me the most interesting example of a great Victorian writer, who by sleight of hand convinces his audience that he is what he is not; a realist. I admit that there are tracts of Dickens that walk where they should fly but no writer can escape the spirit of the age and his was an age suspicious of the more elevated forms of transport. What is remarkable is how much of his work is winged; winged as poems are through the ariel power of words.

The Victorian denial of art as art (separate, Other, self-contained) was unsustainable, and like many a Victorian neurosis began to collapse under its own image. That art should not be art but a version of everyday life was absurd and men like Wilde, Swinburne and Yeats were proving it. The Muse was fighting back, cross-dressed as a pretty young man or dressed in robes of Celtic Twilight. It began to look as though dowdy Realism was dead.

How dead? Phases in literature do not suddenly begin

and just as quickly end, there is a scuffle, an adjustment, and usually a longish period where what is gone and what is coming make their way together. Only by looking backwards do we see the obvious signs of change. The effort to renew in language its poetry, the effort we call Modernism, was not an effort that could cancel out the longeurs of the New Georgians and their fakey pastorals or the high detail of the ageing Victorian novel. The novel was popular and during its determined reign literacy in England had increased measurably. The measure was a vast and newly created reading public who wanted to use a book as we now use television. Sentimental poetry and easy prose were perfect. Realism might be plain but the plain man would pay for it. Against this, it was inevitable that Modernism would be seen as a highbrow, intellectual snob movement cut off from the tastes of the people. The fact is that the tastes of the people were cut off from literature. How could they not be? Mass literacy was not a campaign to improve the culture and sensibility of the nation, it was designed to make the masses more useful. The writer faced another new problem: his public were no longer his educated equals.

Why should that matter? Comparative to the population, art always has been practised by a few and seriously appreciated by a few, usually the ones paying for it, commissioning it, supporting it. During the nineteenth century the most significant social change in Britain was the change from a controlling aristocracy to a controlling plutocracy. We all know the stereotype of New Money puffing on a cigar and ordering in books and pictures by the yard. The trouble is that books and pictures cannot be made

by the yard and nothing is so contradictory to a money culture as art. I am not suggesting that the old system of patronage by Church or Peer was a perfect system or that we should try and return to it. But faced with big business and the average buyer all the arts find that they are being asked to explain themselves in a way that is anathema to their own processes. To support the arts honestly you must either be serious or disinterested. If you are serious you will tolerate and even encourage the necessary experiments and innovations (and failures) that keep art alive. If you are disinterested, recognising that the arts are important even if they move you very little, you will pay the money and leave others to be the judge of your munificence. Roughly speaking, that is how patronage worked until the Industrial Revolution.

What should the poet do? The richest man he knows is Mr Belch who owns the Blacking Factory. Belch's Blacking is a quality product and as everybody knows, quality sells. Belch thinks he would like to support the arts and he fancies having a book of poetry dedicated to him because he thinks that poetry is the ultimate useless commodity and it is a measure of his wealth that he can afford it. He has a look at the poems and judges them pretty awful stuff but he gives the poet money and attaches no conditions to the offer, except an advert in the back and 50 per cent of sales.

The poems do not sell and they are unfavourably reviewed. Belch is furious. Quality Sells. It says so over the gates of his own factory and he has made millions out of it. The poet can't even cover his printing costs. Belch declines

to support the poet's next volume and instead finds a pretty painter whose flowers sell by the roll of canvas.

If business is not interested in the arts, and it isn't, except for tax purposes, advertising lines and conspicuous decoration, then how will the artist support herself if she has no private funds? Sell her work is the obvious answer, but that is not an easy answer when there is often no common ground between purchaser and producer. I do not mean that the writer and the reader should be computer-dating compatible. Some of my favourite books are written by people with whom I doubt that I could spend one hour. In print I can live with them forever because the strong line connecting us is love of language. The connection need not be so esoteric; I am a writer so I will be looking for connections that are not likely to interest the general reader so much. The general reader need not sit down and ponder the runes behind the words, but if he or she wants the pleasure out of a book that cannot be got out of anything else, that reader has forged a link with the writer. A link of commitment to pursue language, the one writing it, the one reading it, a shared belief in a serious endeavour.

It is difficult when the writer is serious and the reader is not. Again, that is a newish problem, reading having become a leisure toy and not a cultural occupation. Of course we read for pleasure, but the enjoyment got out of literature is not the enjoyment to be had from a ball game or a video. I do not want to make a hierarchy among ball games and books; I know that they are pleasures of a different order, I wish that the huge body of readers and sports fans did. Art has been bundled away along with sport and

entertainment and sometimes even charity, but it belongs by itself, a separate reality, a world apart. Readers who don't like books that are not printed television, fast on thrills and feeling, soft on the brain, are not criticising literature, they are missing it altogether. A work of fiction, a poem, that is literature, that is art, can only be itself, it can never substitute for anything else. Nor can anything else substitute for it. The serious writer cannot be in competition for sales and attention with the bewildering range of products from the ever expanding leisure industry. She can only offer what she has ever offered; an exceptional sensibility combined with an exceptional control over words.

How many people want that? Proportionally as few as ever but art is not for the few, it is for many, and I include those who would never pick up a serious fiction or poem and who are uninterested in writing. I believe that art puts down its roots into the deepest hiding places of our nature and that its action is akin to the action of certain delving plants, comfrey for instance, whose roots can penetrate far into the subsoil and unlock nutrients that would otherwise lie out of the reach of shallower bedded plants. In the haste of life and the press of action it is difficult for us to examine our feelings, to express them coherently, to express them poetically, and yet the impulse to poetry which is an impulse parallel to civilisation, is a force towards that range and depth of expression. We do not want language as a list of basic commands and exchanges, we want it to handle matter far more subtle. When we say 'I haven't got the words', the lack is not in the language nor in our emotional state, it is in the

breakdown between the two. The poet heals that break-
down and not only for those who read poetry. If we want a
living language, a language capable of expressing all that it is
called upon to express in a vastly changing world, then we
need men and women whose whole self is bound up in that
work with words.

For the writer, serving the much maligned Muse seems to be
the best way of serving society. When we think about those
writers who have most contributed to the language, we find
that this is so.

That kind of work will never be popular, that is, it will not
please most of the people most of the time. This need not
matter, provided that there are a sufficient number of people
concerned enough for serious work to keep the writer read
and fed. The relationship between the reader and the
writer's work has to be one of trust, for even the most
convinced of readers will not be always convinced. We
come back to those favourite books, inevitably parts of a
writer's work will find more favour than others. To trust is
to submit to the experiment, to stay the course, to sit up late
and wait. Mistakes will be made. No writer is free from
failure and we cannot judge a writer's work until the whole
body of it has appeared, and perhaps we have to wait longer
still. Our own age is very quick to judge and even to pre-
judge, perhaps as part of a determined effort to make sure
that art never opens its own mouth.

It has teeth, art, and a way of cutting through to the soft parts untried.

Did the Modernists too far strain the relationship between reader and writer? I think not. The Romantics had been subjected to invective no less fierce than that aimed at Eliot, Pound, Joyce, Woolf, Stein, HD and company. Revolution upsets order and most of us prefer a quiet life. The revolt against Realism was really a revolt of tradition. The Modernists were trying to return to an idea of art as a conscious place (their critics would say a self-conscious place), a place outside of both rhetoric and cliché. This was a normal enough revolt, and one that had been carried out something over a hundred years earlier by Wordsworth and the Lake poets, and a hundred years before that by Dryden. Periodic refitments in the language poets use have to come at a time when what should be said simply is being said elaborately and when what should be subtle and complex is being too crudely treated. Spoken language alters and poetry, if it is to be living, must move with those changes in language but also stretch them, refine them, so that the thoughts and sensibilities of a people, as reflected in their speech, are kept taut. Poetry, poetic fiction, is not an artificial language (or at least when it is, it ceases to be poetry), but it is a heightened language. It is recognisably the language we all use but at a pitch beyond the every-day capacities of speech.

It is easy to see why, compared with Kipling, Housman, Bridges, and most of the First World War poets (not Owen),

T. S. Eliot's 'Prufrock' (1917) and *The Waste Land* (1922) looked prosy, and were attacked for failing to be poetry. Wordsworth's *Lyrical Ballads* (1798) had been attacked for the same reason. What Eliot was doing was consciously re-linking verse language with street language but refusing to talk down. The language he creates is one flexible enough to stretch around new and difficult ideas and fixed enough within a poetic tradition not to degenerate into a merely private response (always a problem with lesser Moderns, such as Richard Aldington). Whatever it was, it had not been seen before, although it had been anticipated by Robert Browning. Whatever has not been seen before causes trouble. For the ordinary reader, the Modernist writer looked desperately difficult (Eliot) desperately dirty (Joyce) desperately dull (Woolf). Novels were meant to be novels (stories), and poems were meant to be poetic (pastorals, ballads, and during the war, protests). Amongst its other crimes, Modernism was questioning the boundaries between the two. Some very good writers, including Robert Graves, thought this blurring particularly wicked.

If it strikes us as strange that a group of people working towards returning literature to its roots in speech (which is not the same thing as forcing literature down to speech), should be regarded as remote and disconnected, it is worth remembering two things: 1) That we judge new work by a template of the past from which it has already escaped. 2) That the popular novelists and popular poets seemed to be the rightful inheritors of literary tradition because they were perpetuating what had been done well enough and often enough to be familiar. The fact that familiarity usually

means something we no longer question, something we no longer see, is a point in its favour. As creatures of habit, the more we can remove from our immediate consciousness the better. To read something that gives us a certain satisfaction and a certain pleasure, even if its manner and its method is exhausted, is more acceptable than grappling with the new.

Good writers, of any period, write a living language. As their innovations and experiments become commonplace, lesser writers copy them, and in their hands the language is no longer living, it becomes inert. Men like Galsworthy, Bennett and Wells, borrowed from the great Victorian novelists a prose style they and their contemporaries had had no part in forging, and although they borrowed it well, there was nothing of any note that they could add. Even as they were working, speech patterns, and therefore thought patterns and patterns of feeling were rapidly changing. Ours has been a century of rapid change, and if literature is to have any meaning beyond the museum, it must keep developing. To compare the prose style of Woolf's *Jacob's Room* (1922) with Bennett's *Riceyman Steps* (1923) is an exercise in astonishment. Looking now, with hindsight, we can see at once which book is modern, that is to say which style proved the right equipment to put into words that which was only just bubbling into collective consciousness.

That is what I mean when I talk about exceptional sensibility. The true artist does have a kind of early warning system, an immanence that allows him or her to recognise and make articulate the emotional perplexities of his age. Writers who seem to sum up their time are writers who have

this prescience. It is not that they make better documentaries than the rest, this is where the realists miss the point, it is that they make better poems. The emotional and psychic resonance of a particular people at a particular time is not a series of snapshots that can be stuck together to make a montage, it is a living, breathing, winding movement that flows out of the past and into the future while making its unique present. This fixity and flux is never clear until we are beyond it, into a further fixity and flux, and yet when we read our great literature, it seems that it was clear, at least to one group of people, a few out of millions, who come to be absolutely identified with their day; the artists.

Art does not imitate life. Art anticipates life.

Although the major Modernists soon made unblockable inroads into the literary tradition it was inevitable that their purity of purpose would be questioned. The Bloomsbury Group attracted a vengeful type of pseudo-criticism that confused the writer with the work and caricatured both. Art for Art's sake, which was really the chant of Marinetti and the Futurists, stuck to those writers and other artists who seemed stubbornly determined to put the Muse first. The young men (and I do mean men) who were the younger generation in the 1930s, Auden, Isherwood, Spender, Day Lewis, MacNeice, were either Communists or Socialists who passionately believed in a truly popular art. The ivory tower was under siege.

In fact, the stake-out between Ivory Tower and Red

Square was no more real than the apparently conflicting claims of Society and the Muse. While avidly reading and not disputing the innovations of their elders, the new young men wanted to write for the working classes. What they forgot was that the working classes didn't want to read them. As a member of the proletariat myself, I can confirm that there is nothing drearier than the embrace of a bunch of Oxbridge intellectuals who want to tell you that art (theirs) is for you. The express view of the highbrow Moderns was cleaner: *take it or leave it*. What they knew, and what the eager young men of the Thirties reluctantly came to know was that it is not possible to produce a living literature that includes everyone unless everyone wants to be included. Art leaves nobody out, but it cannot condescend, we have to climb up if we want the extraordinary view.

Ours has not been an easy century for art. At times, to talk about it at all has seemed crass. Two World Wars, the Spanish Civil War, the General Strike of 1926 and the Depression of the 1930s cut short those experiments in language and in thought that human beings perpetually make and perpetually need.

For myself, in the literature of my own language, I can find little to cheer me between the publication of *Four Quartets* (1944) and Angela Carter's *The Magic Toyshop* (1967). Of course I am cheered by Beckett and by Pinter and Orton and Stoppard, but they are dramatists and, with the exception of Beckett, the solid body of their work comes out of the 1960s, as does that of Adrienne Rich.

Robert Graves has soldiered on, pledging deep allegiance to his lover-Muse and now that he has been dead ten

years, we see how right he was to go his silly stubborn way and retire to get on with his work. The social conscience lobbies of the Forties and Fifties, including those Angry Young Men, have not worn nearly so well, and it seems that they had not nearly so much to say.

The 1940s and the 1950s seem to me to be a dead time, in my terms because the anti-art response, Realism, bounced back again in a new outfit but wearing the same smug expression. I would hazard that a really good writer, like Muriel Spark, was handicapped by her period. Miss Spark does not want to be a Realist, *The Prime of Miss Jean Brodie* should confirm that, and yet a Realist she has been, and what a pity. Iris Murdoch might have been something else (see *The Black Prince*), and might yet (*The Green Knight*) but I do not worry too much about her.

I do not worry about Kingsley Amis at all.

I would have thought that the rise and rise of TV and film would have entirely satisfied our 'mirror of life' longings. The screen large and small can do perfectly what the ordinary Victorian novel could do, which is why adaptations of same work so well. Adaptations of Dickens do not work well because what gets lost is everything that really matters; language.

As the relationship between reader and writer continues to change, it might be worthwhile to ask what it is that we want from one another. If the reader wants the writer to be an extension of the leisure industry or a product of the media,

then the serious writer will be beaten back into an élitism beyond that necessary to maintain certain standards; it will be an élitism of survival and it is happening already. Writers are fighters, they have to be, because to begin with, they are the people who must stand up for their own work, but must they continually be called to defend not only their own work but the very concept of art? Even to use the word 'art' is to provoke a response either quizzical or violent. If there is no such thing, do we mean that there never has been any such thing, that there is no such thing now, or the writer who is fool enough to use the word simply does not understand it?

We seem to have returned to a place where play, pose and experiment are unwelcome and where the idea of art is debased. At the same time, there are a growing number of people (possibly even a representative number of people), who want to find something genuine in the literature of their own time and who are unconvinced by the glories of reproduction furniture.

To those people I ask this: that their relationship with their writers should be a direct one, the agency of the book is their common ground, and the only way into a piece of literature is through the front door – *Open it*. Once there, if the arrangement of the rooms is unfamiliar and the fabric strange, reflect that at least it is new, and that is what you say you want. It will be too, a world apart, a place where the normal weights and measures of the day have been subtly altered to give a different emphasis and perhaps to slide back the secret panel by the heart. Check that the

book is made of language, living and not inert, for a true writer will create a separate reality and her atoms and her gases are words.

TESTIMONY AGAINST GERTRUDE STEIN

Testimony against Gertrude Stein

Miss Gertrude Stein's memoirs, published last year
under the title of *Autobiography of Alice B. Toklas*, having
brought about a certain amount of controversial com-
ment, Transition has opened its pages to several of those
she mentions who, like ourselves, find that the book
often lacks accuracy. This fact and the regrettable
possibility that many less informed readers might accept
Miss Stein's testimony about her contemporaries, make
it seem wiser to straighten out those points with which
we are familiar before the book has had time to assume
the character of historic authenticity.

To MM. Henri Matisse, Tristan Tzara, Georges
Braque, André Salmon we are happy to give the
opportunity to refute those parts of Miss Stein's book
which they consider require it.

These documents invalidate the claim of the Toklas-
Stein memorial that Miss Stein was in any way con-
cerned with the shaping of the epoch she attempts to

describe. There is a unanimity of opinion that she had no understanding of what really was happening around her, that the mutation of ideas beneath the surface of the more obvious contacts and clashes of personalities during that period escaped her entirely. Her participation in the genesis and development of such movements as Fauvism, Cubism, Dada, Surrealism, Transition etc. was never ideologically intimate and, as M. Matisse states, she has presented the epoch 'without taste and without relation to reality'.

The *Autobiography of Alice B. Toklas*, in its hollow, tinsel bohemianism and egocentric deformations, may very well become one day the symbol of the decadence that hovers over contemporary literature.

EUGENE JOLAS.

Paris, Feb. 1935.

'Without taste and without relation to reality'

Matisse was accusing Gertrude Stein but the irony of his charge was that it summarised precisely the complaints made against the Modernist movement as a whole, including Post-Impressionism and his own work.

'Testimony against Gertrude Stein' was a supplement published with the French literary magazine *Transition* edited by Maria and Eugene Jolas. *Transition* was a vehicle

for new work, it was avowedly experimental, it had published Gertrude Stein on a number of occasions, and was privately funded by the Jolases themselves. Why denounce Stein? Why in 1935?

In 1934 Stein had published the *Autobiography of Alice B. Toklas*. An instant success on both sides of the Atlantic it gave Stein the recognition she had hoped for since *Three Lives* in 1905. Stein had the personality for success; she loved it, and it loved her. She toured, she lectured, she packed halls wherever she went, she told undergraduates at Oxford and Cambridge how to read and how to write. There had been nothing so sensational since the days of Oscar Wilde. In 1934, Gertrude Stein was not on the map, she was the topography of her own country.

I do not think we should dismiss the pack hunt against her as ordinary envy of recognition; Matisse was as famous as their mutual friend, Picasso. Something much more interesting fuelled the fires lit around her: it was the old problem of Representation; Realism, if you like. The quality of lifelikeness which the Cubists had mocked, was raised from its grave as witness against Gertrude Stein. What Stein had done, how it was received by the general reader and how it was received by her co-workers, raises some hard questions about the artist and autobiography.

'Testimony Against Gertrude Stein' fatally assumes that autobiography is a rigid mould into which facts must be poured. That was an odd assumption from a group of men and women, some of them painters, all closely connected to

47

what each would admit was a revolution of form and taste. All of the painters we group as Post-Impressionist (I mean the originators not the later copyists) were accused of misrepresenting both their painterly tradition and their subject matter. Plato was the first person to call the artist a liar, and it is a label used indiscriminately every time new work is produced. We call artists liars by claiming that what they do is not really art because art is really something else; usually whatever previous generations have produced. Matisse called Stein a liar, which is strange from a man who had so often been called a liar himself. To illustrate the point, I quote the following extract from *Art* by Clive Bell. The 1912 exhibition to which he refers was the one at which the British public got their first home view of Post-Impression-ism. Picasso, Matisse and Cézanne were represented. The art critic of *The Times* declared that the frames were worth more than the pictures.

> In the autumn of 1912 I was walking through the Grafton Galleries with a man who is certainly one of the ablest, and is reputed one of the most enlightened, of contemporary men of science. Looking at a picture of a young girl with a cat by Henri Matisse, he exclaimed – 'I see how it is, the fellow's astigmatic.' (A defect in the eye by which rays from one point are not focused as one point.) He assured me at last that no picture in the gallery was beyond the reach of optical diagnostic ... I suggested tentatively that perhaps the discrepancies between the normal man's vision and the pictures on the wall were the result of intentional distortion on the part of the artists. At this, the professor became

passionately serious – 'Do you mean to tell me,' he
bawled, 'that there has ever been a painter who did not
try to make his objects as lifelike as possible? Dismiss
such silly nonsense from your head.'

Matisse's distortions are not faulty Realism, they are a
different kind of reality. A different kind of reality was what
Gertrude Stein was trying to achieve in the *Autobiography of
Alice B. Toklas.*

Gertrude Stein played a trick and it was a very good trick
too. She had, as a precedent, Virginia Woolf's *Orlando*
(1928) but instead of re-making biography into fiction, she
pushed the experiment one step further, and re-defined
autobiography as the ultimate Trojan horse.

We are supposed to know where we are with biography
and autobiography, they are the literary equivalents of the
portrait and the self-portrait. (Reflect a while on what the
Post-Impressionists did with those.) One is the representa-
tion of someone else's life, and the other is the representa-
tion of your own. We shouldn't have to worry about form
and experiment, and we can rest assured that the writer (or
the painter) is sticking to the facts. We can feel safe with
facts. You can introduce a fact to your mother and you can
go out at night with a proven fact on your arm. There we
are; a biography in one hand, and an autobiography in the
other. A rose is a rose is a rose.

Suppose there was a writer who looked despairingly at
her readers and who thought: 'They are suspicious, they
are conservative. They long for new experiences and

deep emotions and yet they fear both. They only feel comfortable with what they know and they believe that art is the mirror of life; someone else's or their own. How to smuggle into their homes what they would normally kill at the gate?'

Bring on the Trojan horse. In the belly of a biography stash the Word. The Word that is both form and substance. The moving word uncaught. Woolf smuggled across the borders of complacency the most outrageous contraband; lesbianism, cross-dressing, female power, but as much as that, and to me more than that, she smuggled her language alive past the checkpoints of propriety.

At similar risk, although Stein is not close to the genius of Woolf, the *Autobiography of Alice B. Toklas* is an act of terrorism against worn-out assumptions of what literature is and what form its forms can take. Modernism fights against fixity of form, not to invite an easy chaos but to rebuild new possibilities. Art cannot move forward by clinging to past discoveries and the re-discovery of form is essential to anyone who wants to do fresh work. Stein knew this as well as Picasso knew it and although she was not as able as he to devise new solutions, she perfectly understood the problem. That in itself makes her a significant writer. The *Autobiography* has been described as a retreat from her experimental style but it was no more a retreat for her than *Orlando* was a compromise for Woolf. Both writers identified and exploited the weak-mindedness of labels. The *Autobiography* is not Gertrude ghosting Alice, it is Gertrude refusing to

accept that real people need to be treated really. She included herself. Gertrude Stein made all of the people around her into characters in her own fiction. I think that a splendid blow to verismo and one which simultaneously questions identity, the nature of truth and the purpose of art. Had anyone said to Matisse 'I don't like that' or 'Your painting is not a proper record of that house/fruit bowl/guitar', Matisse would have laughed in his face. Why then is Matisse complaining that Gertrude has not made a proper record of him?

It was not necessary to agree with the focus of any of Stein's work, or to like it, to know that she was a committed experimenter and that to her, nothing was sacred except the word. Stein never pretended that Toklas had written the book, and even though Stein is named on the jacket as the author, the last paragraph is still one of the wickedest most delightful paragraphs in English literature:

> About six weeks ago Gertrude Stein said, it does not look to me as if you were ever going to write that autobiography. You know what I am going to do? I am going to write it for you. I am going to write it as simply as Defoe did the autobiography of Robinson Crusoe. And she has and this is it.

How could she? The cheek of it. It is an explosion of eighteenth-century wit and Modernist sensibility. The world turned upside down. Poor Matisse. Made into a fiction and determined to behave like a fact. What would he have said

if Stein had rejected the portrait painted of her by Picasso when Picasso blanked out her head?

By refusing to recognise Gertrude Stein's literary adventure her accusers were forced into writs of authenticity. A fact is a fact is a fact. Or is it? Stein was not writing a faithful account of her Paris years, she was vandalising a cliché of literature. Autobiography? Yes, like Robinson Crusoe. Why not daub with bright green paint the smug low wall of assumption?

Gertrude Stein was not an art criminal. The real criminals of art are the ones who parade the efforts of the past as their own work. To force Stein into a kangaroo court because she had no care for convention, is to determine a writer's scope by the prejudices of her readers. What irritated Stein's detractors had little to do with literature. They were falling for the lie they had so often exposed; content above form, subject matter above method. A book cannot be judged by its subject matter any more than a picture can. We need to look at the experiment of the piece. The riskiness of art, the reason why it affects us, is not the riskiness of its subject matter, it is the risk of creating a new way of seeing, a new way of thinking. It does this by overturning the habits and conventions of previous generations. New work is not just topical (although it might be that), it is modern; that is, it has not been done before. What Stein did with the convention of autobiography had not been done before, but her detractors were not (and are not) interested in that.

'Testimony Against Gertrude Stein' never asks any questions about what her *literary* motives might have been, instead, it rages against her 'clinical megalomania', her 'maiden lady greed', her 'Barnumesque publicity', her 'coarse spirit', her 'spiritual depravity'. And what had she done but take a genre and smash it?

Of course there was more to it. Most of what masquerades as literary criticism is a mixture of sexism and self-importance. Stein had trespassed gender as well as social niceties and literary convention. A woman is not allowed to call herself the centre of the world. That she so charmed her ordinary readers is an interesting case of hoax. Like *Orlando* and *Oranges are not the only fruit*, the *Autobiography of Alice B. Toklas* is a fiction masquerading as a memoir. It seems that if you tell people that what they are reading is 'real', they will believe you, even when they are being trailed in the wake of a highly experimental odyssey. I have never understood how anyone can read the Deuteronomy chapter of *Oranges* and not catch on to my game, but then I have never understood how anyone can read the last paragraph of the *Autobiography* and not delight in the plain fact that we have been had. Like Stein, I prefer myself as a character in my own fiction, and like Stein and Woolf, what concerns me is language. Good books are many things, but the most important thing about *Oranges* is not its wit nor its warmth, but its new way with words. A writer is a raider and whatever has been made possible in the past must be

gathered up by her, melted down, and re-formed differently. As she does that, she makes out of her own body a connection to what has gone before and her skull becomes a stepping stone to what will follow. Sometimes we forget that if we do not encourage new work now, we will lose all touch with the work of the past we claim to love. If art is not living in a continuous present, it is living in a museum, only those working now can complete the circuit between the past, present and future energies we call art.

Stein knew this (see her essay 'Composition as Explanation') and the great strength of the *Autobiography* is that Stein the author uses Stein the character as a circuit board to connect up all the pieces of the book. There is an eighteenth-century robustness and raciness in the style of the *Autobiography* as well as the kaleidoscopic fragmentation so typical of Modernism. Stein's process of selection, the way she pinpoints and develops events, is designed to give precisely the giddy out-of-focus feel her detractors complained of. Stein enlarges what is small, reduces what is large, twists and turns her material so that she *can* misrepresent it. The truth of fiction is not the truth of railway timetables. At the same time as undermining our usual way of seeing, Stein the author remains in complete control by making Stein the character absolutely plausible. We doubt nothing about this Stein . . . until we get to the end, when the final paragraph radically alters our reading of the whole. Nevertheless, the *Autobiography* has all the confidence of *A Sentimental Journey* or *Robinson Crusoe* or *Gulliver's Travels*, and it takes on the world with the same gusto as those eighteenth-century authors of whom Stein was fond. Stein had thoroughly

absorbed her reading and like all good writers she is thus able to make a bridge with the past that is both conscious and liminal. I think this is important and only new work can do it, for second-hand work merely repeats the past in a debased habit and, rather than supplying us with the link we need, cuts us off from earlier energies.

An earlier energy that presses upon any discussion of autobiography and the way writers re-invent it, is Words-worth's *The Prelude*. This very long poem, written between 1799 and 1805, was not published until after Wordsworth's death in 1850. Even he had some anxiety about having composed an epic around his own life and offering himself as hero. Had he published *The Prelude* as a young radical rather than as a dead totem, there is no doubt that he would have been thoroughly tarred and feathered with newspaper ink for assuming that the 'Growth of a Poet's Mind' was worthy of the Muse.

We should not underestimate Wordsworth's audacity. Epic poems were to be written around great themes of heroism. Wordsworth makes a long list of such themes in Book 1 of his opus and then decides that the best thing would be to write about himself. I am sure that if *Transition* had been running its offices from the Lake District at the end of the eighteenth century we would now be reading 'Testimony against William Wordsworth'.

The Stein/Wordsworth comparison is instructive. Both writers were able to take a well-known, well-worn form, formula almost, and vitalise it by disrespecting it. It is the

success of either experiment that has led to such common-place misreadings of both texts. The intimacy, the confidence and confidences that charm the reader, are assumed to take their power from their relation to actual life. Nothing could be further from the truth and Wordsworth's famous and infamously abused tag of 'emotion recollected in tranquillity' should give us a clue to the art-process involved, provided that we read the tag rightly.

Wordsworth does not say 'Experience recollected in tranquillity'. To the Romantics and their predecessors, who took for granted a high degree of craft in a writer, the mark of the true poet was his/her sensibility; the exquisiteness of his/her emotional range brought to bear on hard objects. That hard objects should make the poet would have been thought absurd. Wordsworth was not interested in forging actual life into a copy of itself, he was interested in creating a heightened reality.

> I must have exercised
> Upon the vulgar form of present things
> And actual world of our familiar days
> A higher power
>
> (Book 12)

What Wordsworth is bringing back to us from the long tunnel of the past is an emotional rapture that allows us as readers to be deeply moved by experiences not contemporary nor personal to us. This is achieved by the strange gift of true writers to be at once fired by and distant from their material. Tranquillity is not the cosy atmosphere of the fireside pencil, it is the condition of remoteness that allows

the writer artful access to her work. 'Write from your own experience' is fine for the writing class, useless to the writer. What the writer knows has to be put away from her as though she has never known it, so that it is recalled vividly, with the shock of memory after concussion. In the act of writing the emotions of the writer are returned and recharged. They are stronger than before. This is quite opposite to other people's perception of experience and memory.

There is more: not only are the writer's emotions returned and recharged, they are re-drawn. Inside the writer's study, the balance of an ordinary day is overturned. In some ways the overturning is not unlike the effects of LSD. Art alters consciousness, and the consciousness of the writer in the process of writing is not the consciousness of the writer at any other time. Part of the Romantic experiment with drugs (particularly by De Quincey and Coleridge) was an attempt to enhance or induce this altered state, but it is Wordsworth who has left us with the most compelling model of a writer re-ordering his own identity for the purposes of a poem.

When Stein re-ordered her own identity in the *Autobiography of Alice B. Toklas* she was preferring poetic emotion to everyday experience. I do not mean that she was substituting a vague impressionism for the facts of the matter, something her more charitable detractors suggest in the 'Testimony', I mean that she was working up her life into art. Had not James Joyce done the same thing in *A Portrait of the Artist as a*

Young Man (1916)? Stein, like Wordsworth, was more flagrant and less apologetic. She made no attempt to clothe herself in a thin veil of fiction, she became the fiction. By allowing this plasticity to Self, she was able to impose it on Subject. That which is plastic is that which is capable of permanent de-formation without giving way. (Gr. *plastikos*.) Stein's narrative authority has permanently fixed her epoch for generations of readers, but to regard it as documentary would be as grave a mistake as to read *The Prelude* as a Lake District diary.

I hope it is clear that poetic emotion, the emotion recollected by the writer, is not a sloppy, chaotic dogs-tongue of feeling indiscriminately slavered over people and happenings. It is the deep emotion raised up out of the best that we are; emotion of passion, of love, of sex, of ecstasy, of compassion, of grief, of death. It is an operatic largeness. Soap-opera tears are best suited to celluloid. Art is cellular. The emotions it draws upon are fundamental and not always available to the ducts around the eyes. By re-moulding the reality we assume to be objective, art releases to us, realities otherwise hidden

> the soul
> Remembering how she felt, but what she felt
> Remembering not, retains an obscure sense
> of possible sublimity

> (Book 2)

Against daily insignificance art recalls to us possible sublimity. It cannot do this if it is merely a reflection of actual life. Our real lives are elsewhere. Art finds them.

Should people be treated as fictions? The question is an ethical one only if we assume that fiction is a copy of actual life. If we do, then art always is autobiography or biography and the skill of the artist is making it into a pretty toy or perhaps an educational instrument. Art should not drag unwilling actors into its animation. But is this what Gertrude Stein was doing? Or was she insisting on the whole splendid spectacle of her time as fiction in much the same way as the Cubists refused independent authority to hard objects?

Instead of art aspiring towards lifelikeness what if life aspires towards art, towards a creative, controlled focus of freedom, outside of the tyranny of matter? What if the joke about life imitating art were a better joke than we think?

Are real people fictions? We mostly understand ourselves through an endless series of stories told to ourselves by ourselves and others. The so-called facts of our individual worlds are highly coloured and arbitrary, facts that fit whatever fiction we have chosen to believe in. It is necessary to have a story, an alibi that gets us through the day, but what happens when the story becomes a scripture? When we can no longer recognise anything outside of our own reality? We have to be careful not to live in a state of constant self-censorship, where whatever conflicts with our world-view

is dismissed or diluted until it ceases to be a bother. Struggling against the limitations we place upon our minds is our own imaginative capacity, a recognition of an inner life often at odds with the external figurings we spend so much energy supporting. When we let ourselves respond to poetry, to music, to pictures, we are clearing a space where new stories can root, in effect we are clearing a space for new stories about ourselves.

The *Autobiography of Alice B. Toklas*, by refusing to recognise the scriptural authority of actual life, suggests itself and its subject matter as a myriad text open to unlimited interpretation. If we can fictionalise ourselves, and consciously, we are freed into a new kind of communication. It is abstract, light, changeful, genuine. It is what Wordsworth called 'the real solid world of images'. It may be that to understand ourselves as fictions, is to understand ourselves as fully as we can.

A GIFT OF WINGS

(with reference to *Orlando*)

There used to be something called The Canon.

This was regularly used to blast iconoclasts who said terrible things at tea parties, such as 'Surely Katherine Mansfield is as fine a writer as Proust?'

The Canon allowed no debate; it guarded the entry and exit points to the Hall of Fame and stood firmly behind t(T)he t(T)imes.

When not routing offenders in petticoats it fired warning shots over the heads of the uneducated. The Canon was admirably free from modern Existentialist Doubt. It knew who belonged and who didn't belong.

No question.

'Excuse me?'

'Who said that?'

It was Virginia Woolf addressing The Canon.

In her famous exchange with Desmond MacCarthy writing in *The Statesman* as 'Affable Hawk', Woolf fought for her work and fought for her sex, when she laid claim to Sappho as a great poet and argued against a society that hoxes women. Hox is a racing word: it means to hamstring a horse not so brutally that she can't walk but cleverly so that she can't run. Society hoxes women and pretends that God, Nature or the genepool designed them lame.

Woolf had fact on her side when she wrote to an increasingly Irritable Hawk that a measure of economic independence, some privacy, some security, freedom to travel alone, freedom from domestic interruption, and a proper education, would release and redirect a woman's creativity. As example, she was able to use the four great women novelists before her: Jane Austen, Emily Brontë, Charlotte Brontë and George Eliot. Like Woolf, each had obtained a portion of those otherwise male advantages. Like Woolf, none bore children.

Woolf worried about the childlessness from time to time, and suffered from the imposed anxiety that she was not, unlike her friend Vita Sackville-West, a real woman. I do not know what kind of a woman one would have to be to stand unflinchingly in front of The Canon, but I would guess, a real one. There is something sadistic in the whip laid on women to prove themselves as mothers and wives at the same time as making their way as artists. The abnormal effort necessary to produce a true piece of work is not an effort that can be diverted or divided. We all know the story of Coleridge and the Man from Porlock. What of the woman writer and a whole family of Porlocks?

For most of us the dilemma is rhetorical but those women who are driven with consummate energy through a single undeniable channel should be applauded and supported as vigorously as the men who have been setting themselves apart for centuries.

I do not want to think about Virginia Woolf as a would-be mother or a would-be lesbian or a would-be well adjusted nobody if only she had not been sexually abused as a girl. Much has been written about Woolf and much of that much is bulldust. Like T. S. Eliot and D. H. Lawrence, she has suffered from a crazed sub-Freudian approach to her work.

To some, Woolf is a martyr to maleness, to others, a non-practising Sappho. To some, her madness was a weakness, to others, it has been confirmation of her genius and a sign of her spiritual health (to be ill-adjusted to a deranged world is not breakdown). Psychological theories have their interest but to concentrate on the artist takes attention from the art. Virginia Woolf was a great writer, and for us as readers, the only honest undistorted focus is her work.

How to approach it? She is, I think, with the exception of *The Waves*, easy to read. That is, she is easy to read as it is easy to listen to Mozart, easy to look at Cézanne, easy to curl up with Dickens in an armchair by the fire. In Woolf there is much to enjoy in a straightforward open-handed way. Open any of her work at almost any page and you will find fine descriptive passages that have nothing to do with the

watery impressionism of lesser writers. Hooked on a well-thrown line of words, is landed, a fine fat fish. She knows how to draw the world out, breaking the air with colour and the beat of life, and before we can truly admire it at our feet, the line is out on the water again, catch after catch, drawn from the under-depths, the shimmering world that slips through our hands.

> The only resource now left us is to look out of the window. There were sparrows; there were starlings; there were a number of doves, and one or two rooks, all occupied after their fashion. One finds a worm, another a snail. One flutters to a branch, another takes a little run on the turf. Then a servant crosses the courtyard, wearing a green baize apron. Presumably he is engaged on some intrigue with one of the maids in the pantry, but as no visible proof is offered us, in the courtyard, we can but hope for the best and leave it. Clouds pass, thin or thick, with some disturbance of the colour of the grass beneath. The sun-dial registers the hour in its usual cryptic way. One's mind begins tossing up a question or two, idly, vainly, about this same life. Life, it sings, or croons rather, like a kettle on a hob, Life, life, what art thou? Light or darkness, the baize apron of the under footman or the shadow of the starling on the grass?

> Let us go, then, exploring, this summer morning, when all are adoring the plum blossom and the bee. And humming and hawing, let us ask of the starling (who is a more sociable bird than the lark) what he may think on the brink of the dust-bin, whence he picks among the sticks combings of scullion's hair. What's life, we ask,

leaning on the farmyard gate; Life, Life, Life! cries the bird, as if he had heard, and knew precisely, what we meant by this bothering prying habit of ours of asking questions indoors and out and peeping and picking at daisies as the way is of writers when they don't know what to say next. Then they come here, says the bird, and ask me what life is; Life, Life, Life!

We trudge on then by the moor path, to the high brow of the wine-blue purple-dark hill, and fling ourselves down there, and dream there and see there a grasshopper, carting back to his home in the hollow, a straw. And he says (if sawings like his can be given a name so sacred and tender) Life's labour, or so we interpret the whirr of his dust-choked gullet. And the ant agrees and the bees, but if we lie here long enough to ask the moths, when they come at evening, stealing among the paler heather bells, they will breathe in our ears such wild nonsense as one hears from telegraph wires in snow storms; tee hee, haw haw. Laughter, Laughter! the moths say.

Orlando (1928)

A work of art is abundant, spills out, gets drunk, sits up with you all night and forgets to close the curtains, dries your tears, is your friend, offers you a disguise, a difference, a pose. Cut and cut it through and there is still a diamond at the core. Skim the top and it is rich. The inexhaustible energy of art is transfusion for a worn-out world. When I read Virginia Woolf she is to my spirit, waterfall and wine.

Woolf is a fashionable icon nowadays but I do not know how many people actually read her. I do not know how many people have seen a Picasso, not a postcard, the picture. And of those how many, how many slid nothing in between themselves and the work, but looked at it honestly and let it speak? Nevertheless, Picasso is a household name if not a household god and Virginia Woolf is a screen queen.

The power of art is so immense that even its dilutions are homeopathic. Our mental baggage is mostly made up of things we haven't read, haven't heard, haven't seen. And when we do read them, hear them, see them, it is often not as they are in their own right, but through the tiny chink of our own consciousness, a consciousness every day diminished by the battering inanities of the media.

Art is large and it enlarges you and me. To a shrunk-up world its vistas are shocking. Art is the burning bush that both shelters and makes visible our profounder longings. Through it we see ourselves in metaphor. Art is metaphor, from the Greek, *meta* (above) and *pherein* (to carry) it is that which is carried above the literalness of life. Art is metaphor. Metaphor is transformation.

Orlando is metaphor, is transformation, is art.

Published for her friend and sometime lover, Vita Sackville-West, *Orlando* was the book that brought Woolf conspicuous fame. The reading public misunderstood it but it charmed them. It is charming; it has the satisfaction of a romping plot, by turns serious and bizarre. Its historical

sightlines are convincing but wild. Its central character, Orlando, is brave, funny, vulnerable and proud, and has the unusual advantage of being both a man and a woman, a new advantage in fiction, and one previously enjoyed in drama and opera by means of costume change only. Orlando changes her skin.

For Orlando, transformation is sex and sexuality. Orlando pushes through the confines of time, now in a petticoat, now with a cutlass. Love objects, male and female, are appropriately wooed and bedded but not according to the confines of heterosexual desire. The lover knows what it is to be the beloved. The beloved knows in her own body the power of the lover. The Orlando who holds Sasha in his arms is still the Orlando who holds Shelmerdine in hers. Woman to woman, man to man, is the sub-sexuality of Orlando.

These transformations are deliberate. They are saucy. They tease at the reader's hidden doubts and delights in a language that offers the outrageous as perfectly natural if a little surprising.

> And as all Orlando's loves had been women, now, through the culpable laggardry of the human frame to adapt itself to convention, though she herself was a woman, it was still a woman she loved; and if the consciousness of being of the same sex had any effect at all, it was to quicken and deepen those feelings which she had had as a man. For now a thousand hints and mysteries became plain to her that were then dark. Now, the obscurity, which divides the sexes and lets linger innumerable impurities in its gloom, was removed, and

if there is anything in what the poet says about truth and beauty, this affection gained in beauty what it lost in falsity. At last, she cried, she knew Sasha as she was, and in the ardour of this discovery, and in the pursuit of all those treasures which were now revealed, she was so rapt and enchanted that it was as if a cannon ball had exploded at her ear when a man's voice said, 'Permit me, Madam,' a man's hand raised her to her feet; and the fingers of a man with a three-masted sailing ship tattooed on the middle finger pointed to the horizon.

The First Edition of *Orlando* contains a number of photographs of Vita Sackville-West in various costumes, male and female, proclaiming herself as Orlando. The public, who had been expected to avert their gaze from Lady Chatterley and seal their lips against Radclyffe Hall's Stephen Gordon, rushed arm in arm with Orlando. I do not think that transsexual escapades through time threaten the status quo less than cross-class adultery or lesbian love.

It was less obvious. Woolf wanted to say dangerous things in *Orlando* but she did not want to say them in the missionary position. *The Well of Loneliness* and *Lady Chatterley's Lover* both suffer, as art, from tractarianism. I do not mean that art should have nothing to tell us, or that art should keep its hands clean. I do not want to reinforce the charge brought against Bloomsbury by the younger poets of the 1930s; that Woolf and Eliot *et al* fiddled with their syntax while the Western world blew up. Woolf is a writer of social change, although perhaps the kind of challenges she offers have not seemed relevant to men because they are not about them, at least not directly.

Auden disliked Woolf's writing without noticing that what she was most careful to avoid he would have done well to avoid himself. It is the problem of polemic.

Here is Woolf from 'Four Women Novelists'.

> In *Middlemarch* and *Jane Eyre* we are conscious not merely of the writer's character, as we are conscious of the character of Charles Dickens, but we are conscious of a woman's presence, of someone resenting the treatment of her sex and pleading for its rights. This brings into women's writing an element entirely absent from a man's, unless indeed he happens to be a working man or a negro, or who for some reason is conscious of a disability. It introduces a distortion and is frequently the cause of weakness. The desire to plead some personal cause or to make a character the mouthpiece of some personal discontent and grievance always has a distressing effect, as if the point at which the reader's attention is directed were suddenly two-fold instead of single. The genius of Jane Austen and Emily Brontë is never more convincing than in their power to ignore such claims and solicitations . . .

D.H. Lawrence never could resist such claims and solicitations. He was a working-class man with a sermon to preach and whilst I am not one to withhold sympathy from soap-boxers, I know that when rant gets the upper hand, there is no room left for fine writing. And a fine writer was what Lawrence wanted to be, what he is, when he lets

himself. Nobody now reads Lawrence for his rant, he is not the emancipating hero he was in his own time. Only an adolescent would read him for sex. We read him for his writing, the freshness and clarity of language that has survived his own time, his own preoccupations. A good test of art is that it should continue to work on us long after contemporary interest in its ideas or even its subject matter. Lawrence has not survived because he was a reformer, or a thinker, or an iconoclast, there are plenty of those, better than Lawrence, out of print and unread, and who can honestly say that they read Bertrand Russell for his prose? Lawrence has survived because he understood words in their own right, but if his thinking has dated, leaving more space around the language itself, Woolf has been too much in the news. There has been so much concentration on Woolf as a feminist and as a thinker, that the unique power of her language has still not been given the close critical attention it deserves. When Woolf is read and taught, she needs to be read and taught as a poet; she is not a writer who uses for words things, for her, words are things, incantatory, substantial. In her fiction, her polemic is successful because it is subordinated to the right of spells.

The art of *Orlando* is its language. Woolf never lets her words tire and slip. It is the taut line, the tightrope of language, that makes possible passages at once delicate and audacious. Control over her material means control over more than ideas and passions, to feel something acutely, to know something thoroughly is no guarantee of expression. The

artist has a peculiar problem; the strength of emotion necessary to hold together any large piece of work, the heat needed to keep the material supple, can itself fight with the detachment and serenity demanded to make the highly personal voice of the artist into a voice that seems to speak to all. And speak to all, not through a megaphone at a distance, but close up, into the ear. Art is intimacy, lover's talk, and yet it is a public declaration.

Orlando is an intimate book. It calls itself a biography with the same playfulness that Gertrude Stein enjoys in the *Autobiography of Alice B. Toklas*. In either case there is an immediate challenge to conventional genre-boxing but there is too, an invitation to believe. To accept what will follow as truth and as the kind of truth only possible between people who know each other well. The biography and the autobiography both pretend to honesty and frankness, offer to walk with the reader through unknown woods to sights not seen by other people. Both have the whiff of the bedroom about them even if they are not talking about sex. Voyeurism is a vice and a pleasure few of us can deny ourselves and because human beings are always curious and because human beings like to be in on a secret and because human beings are still not sophisticated enough or technological enough or dead enough yet to resist the lure of a good story, we can be taken in by someone who offers truth with a wink and says 'I'm telling you stories. Trust me.'

Woolf's intimate language, that invites confidences and suggests informality, a little *tête-à-tête* between the two of us,

is in fact, highly wrought, highly artificial and resolutely outside the mimicry of Realism. The world she describes is an invented history, with certain key facts as stakes to support her imagination, but the reader should be wary of *Orlando*'s facts, they work too, like wartime signposts, innocently pointing the traveller in the wrong direction. 'This way to Elizabeth the First' really means 'And there you will find Mrs Woolf hiding behind a tree.'

Art is enchantment and artists have the right of spells. I have talked already about Lawrence's faltering, the pauses of incantation where the spell is broken and ordinary life pokes through uninvited. No writer is entirely secure, and everyone knows those dreary passages in Tennyson, in Dickens, in James Joyce, even in T. S. Eliot, who, like Woolf, was watchful, where the taut line of Otherness snaps, and the reader falls abruptly back to earth. The success of later Shakespeare is the success of spells, where every element, however uneven, however incredible, is fastened to the next with perfect authority. The enchanted world shimmers but does not waver. *A Midsummer Night's Dream* is the first of his plays to accomplish this, *The Tempest* is enchantment's apotheosis.

Woolf (like T. S. Eliot) was learned in the Elizabethans, knew how to use them, knew how to read Shakespeare for her own purposes. She knew that the smooth surface of Shakespeare's mature work was the effective cover for jags of matter that lesser dramatists could not harmonise. She knew the dangers of forcing superficial connections and the

disappointment of forging no connections at all. She admired the Renaissance for its efforts to grasp the unruly world whole and tame it through art. (It is perhaps not a surprise, that the Elizabethans were so interested in horse-manship, and that in England in the sixteenth century, we see the beginning of *haute école*.)

Orlando takes a broad canvas of four hundred years, much broader than the contemporary *The Forsyte Saga*, and brings it in to us, not on a series of tea-trays, but on a flying carpet. Woolf's connections across time and space, through the inner and outer worlds of imagination and experience, are made brilliantly, vertiginously, with not a glance over the edge. Cities and peoples pass beneath us, in a moment we are in England, in another moment in Persia, then the carpet flies on, ignoring the claims of the clock. How does she make these connections? Preposterous though they are, they are effective. Why?

She does not do what Huxley and Wells do and tie up her puppets with clever knots. She does not do what Henry James does, and suggest connections that are not apparent. The Jamesian web is a very light one binding here and there without the reader being fully aware of it until he is truly caught. That is not Woolf's method, nor does she borrow from Dickens and bluff her way through when she's stuck. Dickens was a consummate bluffer, and that is, in itself, a very special gift, and those who do not have it by right, should take loan of it gingerly.

Woolf's method of connection is association. English is

an associative language. I do not mean merely that our language is thick with the possibility of puns, something that foreigners, struggling with English, hate, but that images multiply out of the words themselves. Take as an example, the famous speech in *Antony and Cleopatra* – 'The barge she sat in, like a burnish'd throne', or Tennyson's *The Lady of Shalott*, or Edward Lear's nonsense poems, or *Tristram Shandy*. Whatever you think of Ezra Pound, the push of Imagism was to take a hard, sharp word and let it do its full work. Imagism was a battle cry against cloudy language. Where language is cloudy, there can be no bright connections, there can be only the dull, mechanical repetitions of theme or the forcing of ideas, perhaps in themselves extravagant, but unlit. Joseph Conrad's novels have things about them that are interesting but as language they are not interesting. Conrad was a Pole who prided himself on his impeccable and proper English usage. He never understood that the glory of English is in its entirely improper gallops. Its untidiness disturbed him because he did not know how to use it. He never guessed at the wild freedom that is the privilege of the disciplined artist. Conrad, the disciplined pedant, the Salieri of letters, wanted and wrote a fixed English where every word has its own neat meaning and leads neatly and logically passage by passage through his pay-at-the-door show house.

Woolf used the associative method, which is a poet's method, because it suited her temperament and because it suited her material. Like any novelist, she wanted to use the

broad space to handle much matter. She knew the pleasures of the rummaging-den, the piling in of stuff, the fight to make the chaos into an honest order and not a dead and empty catalogue. Unlike many novelists, then and now, she loved words. That is she was devoted to words, faithful to words, romantically attached to words, desirous of words. She was territory and words occupied her. She was night-time and words were the dream.

The dream quality, which is a poetic quality, is not vague. For the common man it is the dream, if at all, that binds together in a new rationale, disparate elements. The job of the poet is to let the binding happen in daylight, to happen to the conscious mind, to delight and disturb the reader when the habitual pieces are put together in a new way. Above all, credulity is not strained. We should not come out of a book as we do from a dream, shaking our heads and rubbing our eyes and saying, 'It didn't really happen.' In poetry, in drama, in opera, in painting, in the best fiction, it really does happen, and is happening all the time, this other place where, as strong and as compelling as our own daily world, as believable, and yet with a very strangeness that prompts us to recall that there are more things in heaven and earth and that those things are solider than dreams.

They may prove solider than real life, as we fondly call the jumble of accidents, characters and indecisions that collect around us without our noticing. The novelist notices, tries to make us clearer to ourselves, tries to set the liquid day, and because of this we read novels. We do hope to see ourselves, as much out of vanity as for instruction.

Nothing wrong with that but there is further to go and it is this further that only poetry can take us. Like the novelist, the poet notices, focuses, sharpens, but for the poet that is the beginning. The poet will not be satisfied with recording, the poet will have to transform. It is language, magic wand, cast of spells, that makes transformation possible.

The poet has an ear that runs in harness with her mind. When Woolf writes she is listening as well as thinking. Rhythm underpins her thought. Rhythm subjects her thought to a discipline more than intellectual. For the poet, words are ideas. An ill-chosen word, a badly written paragraph can escape in the general slackness of the novel in general but in first-rate fiction as in true poetry, there is no escape. Any slackness at once draws attention to itself and if you look at an embarrassing paragraph in a splendid piece of work you will find that it is not the thought at fault. It is the language. This is a very curious thing.

If we admit that language has power over us, not only through what it says but also through what it is, we come closer to understanding the importance of poetry and its function in a healthy society.

If we admit that language has power over us, not only through what it says but also through what it is, we will be tolerant of literary experiment just as we are tolerant of scientific experiment. A writer must resist the pressure of old formulae and work towards new combinations of language.

Woolf can gallop English. She can ride her hobby-horse as hard as Uncle Toby. She can speed the rational world to a blur and halt in a second to make us see for the first time a flower we have trodden on every day. She is not afraid of beauty. She is as sensitive to the natural world as any poet and as physical in response as any lover. She is not afraid of pain. The dark places attract her as well as the light and she has the wisdom to know that not all dark places need light. She has the cardinal virtue of critical courage, sifting her ideas and her impressions through a fine riddle of words, until the clumsiness and the uncertainties drop away, leaving her with word and thing, rare and rich. This work she does as she travels longer and longer distances, hoping we will follow, hoping that she can keep the course. Sometimes she goes too fast or takes a high fence badly. She is unhorsed. She gets back on. Those who do go with her know that her reward, and theirs, is more than a gallop on a fine day, though out of a regiment of foot soldiers, that would be enough. Those who go with her know that the name of her horse is Pegasus. Virginia Woolf has a gift of wings.

A VEIL OF WORDS

(with reference to *The Waves*)

*Like and 'like' and 'like' — but what is the thing
that lies beneath the semblance of the thing?*

The effort of *The Waves* is an effort of exactness. To test experience against language and language against experience is a task that has traditionally been the job of poets. It is the poet who must work at the image until image and meaning can no longer be separated. The force of poetry lies in its exactness.

To say exactly what one means, even to one's own private satisfaction, is difficult. To say exactly what one means and to involve another person is harder still. Communication between you and me relies on assumptions, associations, commonalities and a kind of agreed shorthand, which no-one could precisely define but which everyone would admit exists. That is one reason why it is an effort to have a proper conversation in a foreign language. Even if I am quite fluent, even if I understand the dictionary definitions of words and phrases, I cannot rely on a

shorthand with the other party, whose habit of mind is subtly different from my own. Nevertheless, all of us know of times when we have not been able to communicate in words a deep emotion and yet we know we have been understood. This can happen in the most foreign of foreign parts and it can happen in our own homes. It would seem that for most of us, most of the time, communication depends on more than words.

For the poet, there are words and there are words only. The poet must communicate through language or not communicate at all. If the poet feels an emotion which he or she cannot express, then for effective purposes, the poet does not feel that emotion. The reader is not expected to be psychic, and the reader does not have the poet before her, busily explaining, badly and at great length, what he really means. The poet does not have gesture, physical intimacy, well knownness or fifty-five other books on the subject that he or she can point to. The poet has the poem, made of words, and the reader has the poem, made of words. Often the poet is dead but if the words have been chosen with sufficient prescience the poem will be alive and will continue its work among new generations of readers.

The language poets use is and is not the language that all of us use. For a poet a word carries in itself an abundance of meanings. There is the meaning of the moment, because words alter their meanings, or less drastically, but with equal significance, they alter their associations. Thus the word 'fantastic' which means strictly, a matter of fancy, capricious, wild, has now been almost entirely submerged by its slang meaning of 'excellent'. The poet who is considering

'fantastic' will have to be aware of its strict and its received meaning, but she will have to be aware too of how other poets have used the word. She will have to think of Shakespeare, say, *The Two Gentlemen of Verona*, 'To be fantastique may become a youth of greater time than I shall show to be' (where the context here glosses fantastic as extravagant, unrealistic, foppish even), and she will have to beware of Milton, who had an odd habit of using words arbitrarily. Recall his 'fantastic-footed' nymphs. We know he means their astonishing and other-worldly dancing style but how he means it is by bending the word, not so much as to break it but so as to make it accommodate him. All great poets do this, and inevitably their innovations become the stock of the language. Milton, though, like James Joyce, wanted to be the end-stop of the language. Both men hoped that their work would kill off any other means and any other method. The rest would be decoration merely. Joyce knew this about Milton but the irony seems to have been lost on him. While both men failed in their ambition but succeeded in their literature, the poet has to be wary of their wilful cul-de-sacing. It is often necessary to beat a retreat from the innovations of either man, not because their innovations are final, but because they are unhelpful. Both men carry their eccentricity to the point of a wholly private language. The poet has no use for a wholly private language; it is exactly what he is trying to avoid.

When Virginia Woolf objected to *Ulysses* (1922) on the grounds that 'a great work of art should not be boring', she

was, I think, objecting to the schoolboy scrum of codes and jokes and back-handers, at once self-advertising and self-obscuring. Joyce's freemasonry of language delights scholars, because it gives them something to do, but there is a danger that it appeals only to the acrostic element in most readers. Fathoming Joyce is fun, if you have that kind of mind, but if you do not have that kind of mind, what is fathoming Joyce for?

For itself. Of course. Modernism (in literature) was a poet's movement. Like Woolf, Joyce had a fine ear, and he is entranced by the rhythm of words; the shuffle of words, the march of words, the words that dance, the words that can be choreographed into battle. He is Irish and he lets the words lead him down to the sea, through the strange green waters, until he is returned, salt-washed to the streets of Dublin. His pocketfuls of words, that abrade and glitter, he scatters them, grinds them, and eventually reforms them into a great whale of words, a thousand pages long, that spouts and dives and terrifies and welcomes little men with picks.

He is difficult. Woolf is difficult. Eliot is difficult. A poet's method, because it works towards exactness, is exacting on the reader. The nineteenth-century novel, and I include in there, 95 per cent of English novels written now, in the late twentieth century, is a loose overflowing slack-sided bag. Much can be stuffed into it and much of that without thought. A first-rate prose writer, Dickens, Emily Brontë, who veers unconsciously or perhaps half-guiltily, towards the poetic method, will create something much finer and firmer, but will still leave us with far too much for the journey. Robert Graves was wrong to try and write an

essential, that is, a potted *David Copperfield*, but his irritation with Dickens was not out of place. No writer is safe from the temper of the times, and Dickens wrote feverishly in a feverish age that was made nervous by highbrowism, introspection, and the kind of intensity needed to make poetry. Even Tennyson had to hide his feminine sensibility behind themes of daring-do. There are people who say that if Dickens were alive now, he would be writing soap-operas. He would not but Marie Corelli would.

The poet wants readers. The poet wants to communicate but the poet cannot compromise her method. Not to build the Chinese Wall of a private language and not to slip into conversational slackness are the errors a poet must avoid. Either route has its temptations and when Eliot published *The Waste Land* (1922) he was accused of having followed after both. This is understandable when he and other Modernists were trying simultaneously to find a language that could cope with the multiplicity and fragmentation of the new modern world and yet speak out to an ever-growing body of readers. The average reader (and we must remember that the average reader does not exist before the late nineteenth century) is a product of modern schooling and conservative taste. To be taught to read is not the same thing as to be taught how to read. The average reader demands that he find himself and his world in what he reads, in that the writer must be ever up to date, but at the same time, he demands that the writer's form and style be at least a hundred years out of date. The average reader hates

experiment and suspects innovation of being merely clever-
ness to trick him. He has the writer in an impossible arm-
lock. 'Write about ME,' he says, 'but make your poems
rhyme and give your novels plenty of plot. Don't be fancy
and don't be difficult.' Hence the mass popularity of
Galsworthy and co., and our present day obsession with
reproduction nineteenth-century novels where only the
costumes and the sex have been updated.

Under this kind of pressure, the lesser writer, however
able, is likely to break down into populism or to retreat into
an arid privacy, where only a few others will be welcome.
There is no virtue in being difficult for the sake of being
difficult. The poet's method of exactness is a move towards
a clearer communication and the more blurred everyday
speech has become, the more precise must be the poet. This
can be painful to the reader who is used to travelling through
a lukewarm bubble of noise.

Of the great Modernist triangle, Eliot, Woolf and Joyce,
Woolf seems to me to be the writer most interested in
communication. Eliot put his faith in an élite, Joyce put his
faith in himself, but Woolf, although a self-confessed
highbrow, wants the world in her arms. That is, she sees the
world as her business and her business to return it to itself
again; coherent, whole.

> Science they say, has made poetry impossible; there is no
> poetry in motor cars and wireless. And we have no
> religion. All is tumultuous and transitional. Therefore,
> so people say, there can be no relation between the

poet and the present age. But surely that is nonsense. These accidents are superficial; they do not go nearly deep enough to destroy the most profound and primitive of instincts, the instinct of rhythm ... Let your rhythmical sense wind itself in and out among men and women, omnibuses and sparrows, whatever comes along the street, until it has strung them together in one harmonious whole. That perhaps is your task – to find the relation between things that seem incompatible yet have a mysterious affinity. To absorb every experience that comes your way fearlessly, and saturate it completely so that your poem is a whole and not a fragment; to re-think human life into poetry and so give us tragedy again and comedy by means of characters not spun out at length in the novelist's way, but condensed and synthesised in the poet's way ...

Letter to a Young Poet (1932)

Orlando was one of those happy events in a writer's life, where, without compromising, and indeed while honing her own method, she cuts through to an audience who would usually regard her blankly, if at all. Woolf was delighted with her success but she knew she could not repeat it. To repeat it would have been to copy herself, and no true writer should copy anyone, especially themselves.

In 1931 she published *The Waves* and was dismayed to find that Leonard Woolf had printed up 7,000. 'I'm sure three thousand will feed all appetites then the other four will sit around me for ever like decaying corpses in the studio.'

The Waves was a success, but it was not, at the time, the success of *Orlando*. Since then, its fate has been student bookshelves and university lists and even though it continues to sell all over the world, it is not easy to find someone who simply loves it because it is wonderful. Fortunately I found myself, and I hope that by discussing it now I will coax someone else into dusting it off the shelf and reading it again – for pleasure.

There is not a single sentence in *The Waves* that you would be likely to overhear on the street. Not a single sentence that you would be likely to speak yourself. This is the language we do and do not use. Intelligible, certainly, no Joyceisms, no secret passwords, nothing that cannot be readily construed, and yet and yet it is as strange and mobile as a language of a people undiscovered.
Who are they?
They are ourselves.

Susan, Jinny, Rhoda, Louis, Neville, Bernard. A hexagon of words. Six sides and six angles that form a crystal around the silent figure of Percival who stands perpendicular to their plane.

By refusing Percival a character other than the clean-cut lines of the hero; by denying him speech; by presenting him always through the consciousness of the others, Woolf creates the perfect stable focus for the cluster of altering energy that is the six.

Percival, so straight backed, is the civilised world at the best it can be. Percival inspires devotion, duty, effort, fair play. It is through Percival that the lines of the street steady. But against this sub-text of order and regularity, is the text itself.

> We are only lightly covered with buttoned cloth; and beneath these pavements are shells, bones and silence.

The function of the Victorian novel is not to uncover the world but to recover it; to smooth it out in a matching fabric, to give it a coherence it would not otherwise possess. It is the Victorians, pattern makers and order-givers extraordinary, who are fervent in the religion of art as consolation. It is the Victorians who want to see not the skull beneath the skin but the head dignified even in tragedy. The Renaissance could manage both, and it seems to me that art must manage both if it is to be the right kind of consolation, if it is to reveal a genuine coherence and not one manufactured for the moment. I have said that the best Victorian writers push against the spirit of their age but that they were infected by it. Woolf was remarkably free from a falsity in fiction that has now reached epidemic proportions. Lifting the pavements, she did not lie, she found a language for shells, bones and silence.

This is not going to be the language of shop assistants and tabloids. It is not going to be the cultivated voice of education. It will have to be the language of a poet; heightened, exact, using rhythm not logic as its anchor.

This is hard to read. I am not talking about sense here, or philosophy, or ideas, or content. I mean that the chosen order of the words and the movement they make is so unfamiliar to us, that the experience of reading *The Waves* can be like listening to a piece of classical music that seems at first to have neither narrative nor structure. We are groping for the tune and all we can find are strange intervals and tones and beats. These can sound odd to an ear raised on the tumpety tum of jog-along prose with a melody line to whistle.

The opening is not promising; not promising that is, of narrative and structure as we have come to expect them in the concert afternoon of a well-made novel. We realise straight away, and rather crossly, that we have paid our money and we are not getting programme music.

'I see a ring,' said Bernard, 'hanging above me. It quivers and hangs in a loop of light.'

'I see a slab of pale yellow,' said Susan, 'spreading away until it meets a purple stripe.'

'I hear a sound,' said Rhoda, 'cheep, chirp; cheep, chirp; going up and down.'

'I see a globe,' said Neville, 'hanging down in a drop against the enormous flanks of some hill.'

'I see a crimson tassel,' said Jinny, 'twisted with gold threads.'

'I hear something stamping,' said Louis. 'A great beast's foot is chained. It stamps, and stamps, and stamps.'

Try that at a creative writing class and you will be told it is no way to open a novel. Worse, the novel begins, as all its later

sections do, with a passage about the sun on the waves. The passages are dense and particular. Rush the beginning and you will find yourself plunged too fast into the dialogue above. Take the overture slowly, as it needs to be taken, and you will be at exactly the right pace for the dialogue. It will come as a pleasure, and more than that, it will seem a right necessity.

The pace of Woolf's writing is carefully measured. In *The Waves* the pace is slow. This is not a defect. Nobody would expect to play a piece of music at twice the speed of the score and be able to enjoy it. Yet, in literature this is happening all the time. The reader chooses the pace without taking the trouble to first pick up the rhythm. To get used to a writer's rhythm, to move with a writer's own beat, needs a little bit of time. It means looking at the opening pages carefully. It can help to read them out loud. Much of the delight everyone gets from radio adaptations of classics is a straightforward delight in pace. The actors read much more slowly than the eye passes, especially the eye habituated to scanning the daily papers and skipping through magazines. It is just not possible to read literature quickly. Neither poetry nor poetic fiction will respond to being rushed. In a traditional novel, in a crime novel, in any of the trash novels that come and go, it is easy to skim ahead or to miss out whole sections. To be truthful, there are whole sections of Dickens that should never have been written, therefore they should never be read. Tennyson at his worst is just as guilty. Nevertheless, a real book needs real time, and only by

paying it that small courtesy can a reader begin to unravel it. *The Waves* is not Blackpool beach. There is no use in diving in here and splashing out there. I am sure that 90 per cent of the people who think it boring have never taken the time to read it.

It seems so obvious, this question of pace, and yet it is not. Reviewers, who can never waste more than an hour with a book, are the most to blame. Journalism encourages haste; haste in the writer, haste in the reader, and haste is the enemy of art. Art, in its making and in its enjoying, demands long tracts of time. Books, like cats, do not wear watches.

Over and above all the individual rhythms of music, pictures and words, is the rhythm of art itself. Art objects to the fakeries of clock culture.

This is one reason why it remains anarchic even at its most canonised. The modern world is Time's fool. Art is master of itself.
But, you may say, who has long hours for a book these days? The answer must be whoever wants to read one. A reader must pick up a book, then the reader must pick up the beat. At that moment the clock is stopped.

> Now I am getting his beat into my brain (the rhythm
> is the main thing in writing).

If rhythm, not logic is the anchor of *The Waves*, we should not be misled into thinking the book vague and pretty. It is

not wallpaper. There is not a single unfocused shot in the entire book. Every passage, every sentence, every word, is hard and bright. Where Woolf wants to shade or fade for the sake of effect, she does so as a painter does so, by taking a strong line and manipulating it. This is quite different from a line unfixed or ill-drawn. Anyone can lack power; that is not the way to achieve a subdued tone. A subdued tone that works on us is a strong tone weathered by the artist.

> Alone, I rock my basins; I am mistress of my fleet of ships. But here, twisting the tassels of this brocaded curtain in my hostess's window, I am broken into separate pieces; I am no longer one.

This weathering, the clear image rubbed down until deeper layers of feeling show through is characteristic of Woolf, and part of her tonal capacity. She uses words that will bear inspection, that have association (impossible to read the above and not think of Cleopatra), that can be made to yield up more than their surface function. Nevertheless, the words at face value are strong enough to convey their primary meaning. You need not think of Cleopatra, but if you do, the image will be deeper coloured. A true poet knows that associative or cultural values alone, cannot be relied upon to ferry the meaning from her heart to yours.

She knows that if she is to pierce the thick wall of personality, her arrows, however beautifully decorated, must above all, be sharp.

Popular culture depends for its effects on popular associations. It is something of an in-joke, the product of a

particular people at a particular time. This is why it dates so rapidly. If a piece of work is going to last it will have to have self-definition and depend on nothing but its own power.

Woolf's words are cells of energy. Their relationship to one another increases that energy but the circuit is only complete when the book is taken as a whole. Woolf uses repetition, recurring imagery, particular rhythms for particular speakers, she is adept at plundering the stock of devisings bequeathed to her by her literary ancestors. This makes her a very satisfying writer; if we are interested in literature we want it to be literary. I have used the example of Cleopatra, and it is true that a reader finds pleasure in recognition. Recognition within the work itself; phrasing, notation, and recognition of other work that crowds in to watch this new piece performed. When Woolf writes she writes with generations at her back. There is more. No matter how brilliant, no matter how perfect are certain lines and certain passages, a book, a poem has to work altogether to be complete, and in its completion to cast light on its whole self. At the end of a piece of work there should be a feeling of inevitability; this could not have been made in any other way. At that moment, the watchers draw back, it is not, after all, their book. Here is Sterne, but it is not Sterne's, here is Shakespeare, but it is not Shakespeare's. Donne and Henry James stand in line, and there is that old villain Ben Jonson. The poet is connected, vitally so, but when we close the book there is only one voice we can hear; the writer's

own. It seems as if we are face to face at last and the busy world has disappeared.

Lover's talk? yes. Private language? no. For most of us intimacy demands a private language; pet names, baby talk, double meanings known only to initiates. Thus we communicate across formality, through informality, communicating a confidence in one another and secrets we share. If the poet is not allowed to do this, is she playing a trick? Is she persuading us to feel that we belong when we have never met?

Trick no. Paradox yes. Exactness allows intimacy. The exactness a poet seeks is not the pedantry of the grammarian or the pile of dead bodies to be found in any technical manual. It is the same inspiration of relationship that the painter seeks, that the architect seeks, that the musician seeks. It is a harmony of form. A close balanced series of weights and measures and proportions that agree with one another and that agree as a whole. Poets and cathedrals sing.

The language of *The Waves* is the language of rapture. For some people this is embarrassing. The twentieth century, in the footsteps of the nineteenth, has difficulty with the notion of art as ecstasy. Yet that is the traditional notion and I believe it is the right one. It is quite easy to live at a low level of sensibility; it is the way of the world. There is no need to ask art to show us how to be less than we are. Art shows us how to be more than we are. It is heightened, grand, an act

of effrontery. It is a challenge to the confines of the spirit. It is a challenge to the comfortable pleasures of everyday life. There is in art, still, something of the medieval mystic and something of the debauch. Art is excess. The fiery furnace, the freezing lake. It summons extremes of feeling, those who denounce it and its makers, do so violently. Those who fall in love, with that picture, that book, do so passionately. Once encountered, art will get a response. My worry is, that the media, like some hideous chaperone, shoves its burly form in between the audience and the art and prevents close encounters of the real kind. Turn off the television and slip away . . .

The language of rapture.

> Your days and hours pass like the boughs of forest trees and the smooth green of forest rides to a hound running on the scent. But there is no single scent, no single body for me to follow. And I have no face. I am like the foam that races over the beach or the moonlight that falls here on a tin can, here on a spike of mailed sea holly, or a bone or a half-eaten boat. I am whirled down caverns and flap like paper against endless corridors and must press my hand against the wall to draw myself back.

There is no fight between exactness and rapture. *The Waves* is carried away by its own words. The words in rhythmic motion in and out, preoccupying, echoing, leaving a trail across the mind.

Rapture is a state of transformation. Woolf lifts up the

veil of words that filmy or thick hides myself from the moment, you from me. These are not words to hide behind. These are not words to pad me against emotion or to be chanted as a prayer to make life safer than it is. These are words that cut through the semblance of the thing to the thing itself. Against the blunted days of approximation comes the clarity of the Word. This is frightening, this is a relief. This is what I have been hoping for and what I fear. I do not want to be exposed under language in this way. I do not want to face the cross-section of my heart. Do I want an act of clear seeing in a world that keeps its hands over its eyes? Human kind cannot bear very much reality. Reality of language, rapture of language, exactness of words that has found me out. Words that wipe clean the dirt on the window-pane leave me with an unexpected view.

Of what? Myself and strangers. The horror and the glory. All that I have made such an effort to avoid.

The language of rapture.

> That would be a glorious life, to addict oneself to perfection; to follow the curve of the sentence wherever it might lead, into deserts, under drifts of sand, regardless of lures, of seductions; to be poor always and unkempt; to be ridiculous in Piccadilly.

In Piccadilly rapture is ridiculous and we are encouraged to be Piccadilly men and women. The language of *The Waves* is so outside the fumblings of tidy mouths that it can read like an insult. It is a 200-page insult to mediocrity.

It is the insult of the saint to pragmatists everywhere.

It is the insult of the rake to the marriage bed.

It is the insult of excellence against institution. It is the age-old insult of art.

How dare she? *The Waves* is in dialogue but men and women never talk that way. The words are not difficult, Latinate or obscure. No-one need consult a dictionary to read this book. The grammar is not exotic. The syntax is hardly ever arcane. It would be easy to paraphrase any page. And yet, and yet, this is not a language we have learned at school or in the company of our kind. If we were fair we would say 'I would talk like this if I could talk poetry.' The emotional experience of *The Waves* is not class-bound. It is not the rarified world of the better-off before the war. If the language seems remote it is because we are remote from our own rapture.

Trust it. Art is an act of faith; first for the artist herself and foremost for the audience. It is necessary to believe that there is something here worth having and to persevere into the other world of the artist which will reveal itself with a little work and a little patience. It is a love-affair and anyone who has fallen in love will know that outside of that moment of recognition, the beloved is only another face among faces. What changes is not the beloved but our perception of her.

I do not say that *The Waves* will be a love-affair for everyone. I do say that there is much here to love.

The language of rapture.

When reading Woolf we have to be careful of the resistances built up in us by our social and emotional training. The state, the family, the way most of us are educated, dampens down spontaneous feeling and makes us wary of excess. Woolf, in her lifetime, suffered from an invalidish image, a spinster type of delicacy which is supposed to make her work, delicate, fragile, beautiful maybe, but out of touch and not robust. Woolf, as a woman, was no more invalidish or fussy than James Joyce, as a man, with his chronic eye trouble and ferocious migraines.

I see no reason to read into Woolf's work the physical difficulties of her life. If I said to you that a reading of John Keats must entertain his tuberculosis and the fact that he was common and short, you would ignore me. You should ignore me; a writer's work is not a chart of their sex, sexuality, sanity and physical health. We are not looking to enlist them in the navy we are simply trying to get on with the words. Many readers, especially men, think that they dislike Woolf because her work is ethereal and dreamy. They conjure up a picture of the Bloomsbury madwoman and put her books away. I argue that it is not Woolf's remoteness that puts people off but her nearness that terrifies them. Her language is not a woolly blanket it is a sharp sword. *The Waves*, which is the most difficult of her works,

is a strong-honed edge through the cloudiness most of us call life. It is uncomfortable to have the thick padded stuff ripped away. There is no warm blanket to be had out of Virginia Woolf; there is wind and sun and you naked. It is not remoteness of feeling in Woolf, it is excess; the unbearable quiver of nerves and the heart pounding. It is exposure.

And it is exactness.

Art always dresses for dinner. Does this seem stuffy in the jeans and T-shirt days of popular culture? Perhaps, but without a formal space art cannot do its work. To be exact is to clear away the clutter from what is essential. Informality breeds clutter and to call something informal has become a euphemism for disorganisation. Disorganised people live and work in clutter and they make clutter for others. Contrary to the bohemian stereotype, the true artist is highly organised and must constantly select and order her material, choosing only that which can be shaped to an ultimate purpose. This can be daunting for anyone who believes that the word 'relaxed' has a higher human value than the word 'disciplined'. To read *The Waves* is to collide violently with a discipline of emotion and language that heightens both to a point of painful beauty. There is no compromising with this book; either you read it on its own terms or you cannot read it at all. No-one would expect to play cricket according to the rules of ping-pong and it is unreasonable to come at any

work of art and blame it for not happening as you think it should.

The Waves is not an easy book to master but it never tires and it never fades. If you do wrestle with it and find the spring of its opening it will be a place to rest in all the days of your life.

It will give you too, what all art promises; a greater pleasure in the moment and a sense of permanencies. It is not time-locked and it will unlock for you a history otherwise hidden; the history of the human heart. I know of no better communicator than art. No better means of saying so precisely those things which need so urgently to be said. It has been a baton handed on to us across centuries and through difference. It is an act of courage.

> Line and colours almost persuade me that I too can be heroic.

PART THREE

ECSTASY
AND
ENERGY

THE SEMIOTICS
OF SEX

I was in a bookshop recently when a young woman approached me.

She told me she was writing an essay on my work and that of Radclyffe Hall. Could I help?

'Yes,' I said. 'Our work has nothing in common.'

'I thought you were a lesbian,' she said.

I have become aware that the chosen sexual difference of one writer is, in itself, thought sufficient to bind her in semiotic sisterhood with any other writer, also lesbian, dead or alive.

I am, after all, a pervert, so I will not mind sharing a bed with a dead body. This bed in the shape of a book, this book in the shape of a bed, must accommodate us every one, because, whatever our style, philosophy, class, age, pre-occupations and talent, we are lesbians and isn't that the golden key to the single door of our work?

In any discussion of art and the artist, heterosexuality is backgrounded, whilst homosexuality is foregrounded.

What you fuck is much more important than how you write. This may be because reading takes more effort than sex. It may be because the word 'sex' is more exciting than the word 'book'. Or is it? Surely that depends on what kind of sex and what kind of book? I can only assume that straight sex is so dull that even a book makes better reportage. No-one asks Iris Murdoch about her sex life. Every interviewer I meet asks me about mine and what they do not ask they invent. I am a writer who happens to love women. I am not a lesbian who happens to write.

What is it about? Prurience? Stupidity? And as Descartes didn't say, 'I fuck therefore I am.'? The straight world is wilful in its pursuit of queers and it seems to me that to continually ask someone about their homosexuality, when the reason to talk is a book, a picture, a play, is harassment by the back door.

The Queer world has colluded in the misreading of art as sexuality. Art is difference, but not necessarily sexual difference, and while to be outside of the mainstream of imposed choice is likely to make someone more conscious, it does not automatically make that someone an artist. A great deal of gay writing, especially gay writing around the Aids crisis, is therapy, is release, is not art. It is its subject matter and no more and I hope by now that I have convinced my readers in these essays, that all art, including literature, is much more than its subject matter. It is true that a number of gay and lesbian writers have attracted an audience and some attention simply because they are queer. Lesbians and gays do need their own culture, as any sub-group does, including the sub-group of heterosexuality, but

the problems start when we assume that the fact of our queerness bestows on us special powers. It might make for certain advantages (it is helpful for a woman artist not to have a husband) but it cannot, of itself, guarantee art. Lesbians and gay men, who have to examine so much of what the straight world takes for granted, must keep on examining their own standards in all things, and especially the standards we set for our own work.

I think this is particularly urgent where fiction and poetry are concerned and where it is most tempting to as-sume that the autobiography of Difference will be enough.

Let me put it another way: if I am in love with Peggy and I am a composer I can express that love in a ensemble or a symphony. If I am in love with Peggy and I am a painter, I need not paint her portrait, I am free to express my passion in splendid harmonies of colour and line. If I am a writer, I will have to be careful, I must not fall into the trap of believing that my passion, of itself, is art. As a composer or a painter I know that it is not. I know that I shall have to find a translation of form to make myself clear. I know that the language of my passion and the language of my art are not the same thing.

Of course there is a paradox here; the most powerful written work often masquerades as autobiography. It offers itself as raw when in fact it is sophisticated. It presents itself as a kind of diary when really it is an oration. The best work speaks intimately to you even though it has been consciously made to speak intimately to thousands of others. The bad writer believes that sincerity of feeling will be enough, and pins her faith on the power of experience. The true writer

knows that feeling must give way to form. It is through the form, not in spite of, or accidental to it, that the most powerful emotions are let loose over the greatest number of people.

Art must resist autobiography if it hopes to cross boundaries of class, culture . . . and . . . sexuality. Literature is not a lecture delivered to a special interest group, it is a force that unites its audience. The sub-groups are broken down.

How each artist learns to translate autobiography into art is a problem that each artist solves for themselves. When solved, unpicking is impossible, we cannot work backwards from the finished text into its raw material. The commonest mistake of critics and biographers is to assume that what holds significance for them necessarily held significance for the writer. Forcing the work back into autobiography is a way of trying to contain it, of making what has become unlike anything else into what is just like everything else. It may be that in the modern world, afraid of feeling, it is more comfortable to turn the critical gaze away from a fully realised piece of work. It is always easier to focus on sex. The sexuality of the writer is a wonderful diversion.

If Queer culture is now working against assumptions of identity as sexuality, art gets there first, by implicitly or explicitly creating emotion around the forbidden. Some of the early feminist arguments surrounding the wrongfulness

of men painting provocative female nudes seem to me to have overlooked the possibility or the fact of another female as the viewer. Why should she identify with the nude? What deep taboos make her unable to desire the nude?

Opera, before and after the nineteenth century, but not during, enjoyed serious games of sexual ambiguity, and opera fans will know the delicious and disturbing pleasure of watching a woman disguised as a man and hearing her woo another woman with a voice unmistakably female. Our opera ancestors knew the now forbidden pleasure of listening to a man sing as a woman; in his diary, Casanova writes of the fascination and desire felt for these compromising creatures by otherwise heterosexual men. Music is androgynously sexy and with the same sensuous determination penetrates male and female alike. Unless of course one resists it, and how much sex-resistance goes on under the lie of 'I don't like opera.'?

Similarly, I am sure that a lot of the coyness and silliness that accompanies productions of Shakespeare that include cross-dressing roles, is an attempt to steer them clear of Queer. As long as we all know that a pretence is happening; the pretence of Principal Boy or music-hall camp, we are safe in our het-suits. Too many directors overlook the obvious fact that in Shakespeare, the disguises are meant to convince. They are not a comedian's joke. We too must fall in love. We too must know what it is to find that we have desired another woman, desired another man. And should we really take at face value those fifth acts where everyone simply swops their partner to the proper sex and goes home to live happily ever after?

I am not suggesting that we should all part with our husbands and live Queer.

I am not suggesting that a lesbian who recognises desire for a man sleep with him. We need not be so crude. What we do need is to accept in ourselves, with pleasure, the subtle and various emotions that are the infinity of a human being. More, not less, is the capacity of the heart. More not less is the capacity of art.

Art coaxes out of us emotions we normally do not feel. It is not that art sets out to shock (that is rare), it is rather that art occupies ground unconquered by social niceties. Seeking neither to please nor to displease, art works to enlarge emotional possibility. In a dead society that inevitably puts it on the side of the rebels. Do not mistake me, I am not of the voting party of bohemians and bad boys, and the rebelliousness of art does not make every rebel an artist. The rebellion of art is a daily rebellion against the state of living death routinely called real life.

> Where every public decision has to be justified in the scale of corporate profit, poetry unsettles these apparently self-evident propositions, not through ideology, but by its very presence and ways of being, its embodiment of states of longing and desire.
>
> Adrienne Rich, *What is Found There: Notebooks on Poetry and Politics* (1993)

And not only public decisions but also private compromises. Calculations of the heart that should never be made. It is through the acceptance of breakdown; breakdown of fellowship, of trust, of community, of communication, of

language, of love, that we begin to break down ourselves, a fragmented society afraid of feeling.

Against this fear, art is fresh healing and fresh pain. The rebel writer who brings healing and pain, need not be a Marxist or a Socialist, need not be political in the journalistic sense and may fail the shifting tests of Correctness, while standing as a rebuke to the hollowed out days and as a refuge for our stray hearts. Communist and People's Man, Stephen Spender, had the right credentials, but Catholic and cultural reactionary T. S. Eliot made the poetry. It is not always so paradoxical but it can be, and the above example should be reason enough not to judge the work by the writer. Judge the writer by the work.

When I read Adrienne Rich or Oscar Wilde, rebels of very different types, the fact of their homosexuality should not be uppermost. I am not reading their work to get at their private lives, I am reading their work because I need the depth-charge it carries.

Their formal significance, the strength of their images, their fidelity to language makes it possible for them to reach me across distance and time. If each were not an exceptional writer, neither would be able to reach beyond the interests of their own sub-group. The truth is that both have an audience who do not share the sexuality or the subversiveness of playwright and poet but who cannot fail to be affected by those elements when they read Rich and Wilde. Art succeeds where polemic fails.

Nevertheless, there are plenty of heterosexual readers who won't touch books by Queers and plenty of Queer readers who are only out to scan a bent kiss. We all know of

men who won't read books by women and in spite of the backlash that dresses this up in high sounding notions of creativity, it is ordinary terror of difference. Men do not feel comfortable looking at the world through eyes that are not male. It has nothing to do with sentences or syntax, it is sexism by any other name. It would be a pity if lesbians and gay men retreated into the same kind of cultural separatism. We learn early how to live in two worlds; our own and that of the dominant model, why not learn how to live in multiple worlds? The strange prismatic worlds that art offers? I do not want to read only books by women, only books by Queers, I want all that there is, so long as it is genuine and it seems to me that to choose our reading matter according to the sex and/or sexuality of the writer is a dismal way to read. For lesbians and gay men it has been vital to create our own counter-culture but that does not mean that there is nothing in straight culture that we can use. We are more sophisticated than that and it is worth remembering that the conventional mind is its own prison.

The man who won't read Virginia Woolf, the lesbian who won't touch T. S. Eliot, are both putting subjective concerns in between themselves and the work. Literature, whether made by heterosexuals or homosexuals, whether to do with lives gay or straight, packs in it supplies of energy and emotion that all of us need. Obviously if a thing is not art, we will not get any artistic pleasure out of it and we will find it void of the kind of energy and emotion we can draw on indefinitely. It is difficult, when we are surrounded by trivia makers and trivia merchants, all claiming for them- selves the power of art, not to fall for the lie that there is no

such thing or that it is anything. The smallness of it all is depressing and it is inevitable that we will have to whip out the magnifying glass of our own interests to bring the thing up to size. 'Is it about me?' 'Is it amusing?' 'Is it dirty?' 'What about the sex?' are not aesthetic questions but they are the questions asked by most reviewers and by most readers most of the time. Unless we set up criteria of judgement that are relevant to literature, and not to sociology, entertainment, topicality etc., we are going to find it harder and harder to know what it is that separates art from everything else.

Learning to read is more than learning to group the letters on a page. Learning to read is a skill that marshals the entire resources of body and mind. I do not mean the endless dross-skimming that passes for literacy, I mean the ability to engage with a text as you would another human being. To recognise it in its own right, separate, particular, to let it speak in its own voice, not in a ventriloquism of yours. To find its relationship to you that is not its relationship to anyone else. To recognise, at the same time, that you are neither the means nor the method of its existence and that the love between you is not a mutual suicide. The love between you offers an alternative paradigm; a complete and fully realised vision in a chaotic unrealised world. Art is not amnesia, and the popular idea of books as escapism or diversion, misses altogether what art is. There is plenty of escapism and diversion to be had, but it cannot be had from real books, real pictures, real music, real theatre. Art is the realisation of complex emotion.

We value sensitive machines. We spend billions of pounds
to make them more sensitive yet, so that they detect minerals
deep in the earth's crust, radioactivity thousands of miles
away. We don't value sensitive human beings and we spend
no money on their priority. As machines become more
delicate and human beings coarser, will antennae and fibre-
optic claim for themselves what was uniquely human? Not
rationality, not logic, but that strange network of fragile
perception, that means I can imagine, that teaches me to
love, a lodging of recognition and tenderness where I
sometimes know the essential beat that rhythms life.

The artist as radar can help me. The artist who combines
an exceptional sensibility with an exceptional control over
her material. This equipment, unfunded, unregarded, gift
and discipline kept tuned to untapped frequencies, will
bring home signals otherwise lost to me. Will make for my
ears and eyes what was the property of the hawk. This
sharpness and stretch of wings has not in it the comfort of
escape. It has in it warnings and chances and painful beauty.
It is not what I know and it is not what I am. The mirror
turns out to be a through looking-glass, and beyond are
places I have never reached. Once reached there is no need
to leave them again. Art is not tourism it is an ever-
expanding territory. Art is not Capitalism, what I find in it,
I may keep. The title takes my name.

The realisation of complex emotion.

Complex emotion is pivoted around the forbidden. When I
feel the complexities of a situation I am feeling the many-

sidedness of it, not the obvious smooth shape, grasped at once and easily forgotten. Complexity leads to perplexity. I do not know my place. There is a clash between what I feel and what I had expected to feel. My logical self fails me, and no matter how I try to pace it out, there is still something left over that will not be accounted for. All of us have felt like this, all of us have tried to make the rough places smooth; to reason our way out of a gathering storm. Usually dishonesty is our best guide. We call inner turbulence 'blowing things up out of all proportion'. We call it 'seven-year itch'. We call it 'over-tiredness'. Like Adam we name our beasts, but not well, and we find they do not come when called.

Complex emotion often follows some major event in our lives; sex, falling in love, birth, death, are the common-est and in each of these potencies are strong taboos. The striking loneliness of the individual when confronted with these large happenings that we all share, is a loneliness of displacement. The person is thrown out of the normal groove of their life and whilst they stumble, they also have to carry a new weight of feeling, feeling that threatens to overwhelm them. Consequences of misery and breakdown are typical and in a repressive society that pretends to be liberal, misery and breakdown can be used as subtle punishments for what we no longer dare legislate against. Inability to cope is defined as a serious weakness in a macho culture like ours, but what is inability to cope, except a spasmodic, faint and fainter protest against a closed-in drugged-up life where suburban values are touted as the greatest good? A newborn child, the moment of falling in love, can cause in us seismic shocks that will, if we let them,

help to re-evaluate what things matter, what things we take for granted. This is frightening, and as we get older it is harder to face such risks to the deadness that we are. Art offers the challenge we desire but also the shape we need when our own world seems most shapeless. The formal beauty of art is threat and relief to the formless neutrality of unrealised life.

'Ah' you will say, 'She means Art as Consolation. The lonely romantic who reads Jane Eyre. The computer misfit wandering with Wordsworth.'

I do not think of art as Consolation. I think of it as Creation. I think of it as an energetic space that begets energetic space. Works of art do not reproduce themselves, they re-create themselves and have at the same time sufficient permanent power to create rooms for us, the dispossessed. In other words, art makes it possible to live in energetic space.

When I talk about creating emotion around the forbidden, I do not mean disgust around the well known. Forget the lowlife, tourist, squeaky clean middle-class bad boys who call their sex-depravity in blunt prose, fine writing. Forget the copycat girls who wouldn't know the end of a dildo from a vacuum rod. They are only chintz dipped in mud and we are after real material. What is forbidden is scarier, sexier, unnightmared by the white-collar cataloguers of crap.

'Don't do that' makes for easy revolt. What is forbidden is hidden. To worm into the heart and mind until what one truly desires has been encased in dark walls of what one ought to desire, is the success of the serpent. Serpents of state, serpents of religion, serpents in the service of education, monied serpents, mythic serpents, weaving their lies backwards into history. Two myths out of many: the first, Hebrew: Eve in the garden persuaded to eat that which she has never desired to eat ('The serpent bade me eat'). The second, Greek: Medusa, the Gorgon, whose serpent hair turns all who look on her to stone.

There are many ways of reading these myths, that is the way with myths, but for the purposes of this argument, I want us to be wary of bodies insinuated to desire what they do not desire and of hearts turned to stone.

How can I know what I feel? When a writer asks herself that question she will have to find the words to answer it, even if the answer is another question. The writer will have to make her words into a true equivalent of her heart. If she cannot, if she can only hazard at the heart, arbitrarily temporarily, she may be a psychologist but she will not be a poet.

It is the poet who goes further than any human scientist. The poet who with her dredging net must haul up difficult things and return them to the present. As she does this, the reader will begin to recognise parts of herself so neatly buried that they seem to have been buried from birth. She will be able to hear clearly the voices that have whispered at her for so

many years. Some of those voices will prove false, she will perhaps learn to fear her own fears. The attendant personalities that are clinically labelled as schizophrenia, can be brought into a harmonious balance. It is not necessary to be shut up in one self, to grind through life like an ox at a mill, always treading the same ground. Human beings are capable of powered flight; we can travel across ourselves and find that self multiple and vast. The artist knows this; at the same time that art is prising away old dead structures that have rusted almost unnoticed into our flesh, art is pushing at the boundaries we thought were fixed. The convenient lies fall; the only boundaries are the boundaries of our imagination.

How much can we imagine? The artist is an imaginer. The artist imagines the forbidden because to her it is not forbidden. If she is freer than other people it is the freedom of her single allegiance to her work. Most of us have divided loyalties, most of us have sold ourselves. The artist is not divided and she is not for sale. Her clarity of purpose protects her although it is her clarity of purpose that is most likely to irritate most people. We are not happy with obsessives, visionaries, which means, in effect, that we are not happy with artists. Why do we flee from feeling? Why do we celebrate those who lower us in the mire of their own making while we hound those who come to us with hands full of difficult beauty?

If we could imagine ourselves out of despair?

If we could imagine ourselves out of helplessness?

What would happen if we could imagine in ourselves authentic desire?

What would happen if one woman told the truth about herself? The world would split open.

<div align="right">Muriel Rukeyser</div>

In search of this truth, beyond the fear of the consequences of this truth, are the flight-maps of art. When truth is at stake, and in a society that desperately needs truth, we have to be wary of those side-tracks to nowhere that mislead us from the journey we need to make. There are plenty of Last Days signposts to persuade us that nothing is worth doing and that each one of us lives in a private nightmare occasionally relieved by temporary pleasure.

Art is not a private nightmare, not even a private dream, it is a shared human connection that traces the possibilities of past and future in the whorl of now. It is a construct, like science, like religion, like the world itself. It is as artificial as you and me and as natural too. We have never been able to live without it, we have never been able to live with it. We claim it makes no difference whilst nervously barring it out of our lives. Part of this barring is to gender it, to sex it, to find ways of containing and reducing this fascinating fear. But to what are our efforts directed? What is it that we seek to mock and discourage? It is the human spirit free.

I was in a bookshop recently and a young man came up to
me and said
'Is Sexing the Cherry a reading of Four Quartets?'
'Yes,' I said, and he kissed me.

THE PSYCHOMETRY
OF BOOKS

Book collecting is an obsession, an occupation, a disease, an addiction, a fascination, an absurdity, a fate. It is not a hobby. Those who do it must do it. Those who do not do it, think of it as a cousin of stamp-collecting, a sister of the trophy cabinet, bastard of a sound bank account and a weak mind. Money you must have, although not necessarily in large quantities, but certainly in disposable amounts. What makes money disposable is a personal question. My first First Edition was bought courtesy of a plastic sheet nailed over a rotten window. The price of fitting a new frame and glass was the price of Robert Graves: *To Whom Else?* Seizan Press, 1931, hand-set, cover by Len Lye.

Why choose the insistence of winter and a book? I took it home, lit my fire and made a proper sacrifice of my comfort. Snow and hail are nothing to happiness and I was happy. Two hundred copies and one was mine.

Signed and dated of course. I insist on that. The dealer from whom I bought it called it autograph hunting. I was

young and he was worldly-wise, a big bear, a talking bear, who roamed expensive forests and grandly handed me my acorn.

Some years later I bought from him an oak: Virginia Woolf, *Jacob's Room*, 1922. As he said, expensive, but so rare to find one signed . . .

Rareness is all. Or is it? Not to the romantic collector who has fallen in love. Not to Don Juan who always finds a beauty on the shelf. If you love books as objects, as totems, as talismans, as doorways, as genii bottles, as godsends, as living things, then you love them widely. This binding, that paper. Strange company kept. Like women, the most exciting have had a lively past. One of my favourites in my own harem is a copy of *The One Who Is Legion* (1930) by Natalie Barney and given by her with a fond inscription to her lover, the painter Romaine Brooks.

Soul and body have no bounds . . .

What is the relationship between the inner and outer? Between the text and its context? Why a signed First Edition and not a Penguin Classic?

The prosaic answer, the answer of the investor, would be bibliographical; that many of the now recognised classics, not having been recognised as classics at the time of their printing, were issued singly or separately, if they were

poems, and in extremely limited or private press editions in the case of both poetry and prose. Such editions are beautiful even at their most workmanlike. They are a durable pleasure. They are, without any self-consciousness, what The Folio Society and its kind would like to be. They are worth possessing in their own right. They are original just as the texts they wrap are original. The making of a book and the creating of a book come together only once in the history of a book. The text will transcend its time, the wrapper and the binding and the paper and the ink and the signature and the dedication can't. All that is caught (or lost) at a single moment. All that becomes a reminder, a museum, a backwards eye into a forgotten place. As historical objects, as antiques, First Editions have all the virtues necessary to a collector; archival interest, market value, display, rarity, temptation.

For the lover, who collects in order to keep the beloved ever by her side, there is more than virtue, there is passion.

I was brought up without books. An early unprinted existence where paper was something pasted on to walls and likely reading matter was either The Bible or the Army and Navy Stores catalogue, always open at underwear.

There was nothing perverted in this; without proper heating and in chilly Lancashire, a thermal one-piece was the essence of God; all-protecting, embracing, saving, generous. I still have a talent for sleeved vests, although mine now come from the Burlington Arcade, but without one of my early cast-offs, I might never have been brave enough to buy

that first First Edition. I am wearing one now, book and vest. I have been wearing one since I was a small child, book and vest. Books and vests bound up together. Both protect me.

Brought up without books, my passion for them was, if not directly forbidden, discouraged. At that time I knew nothing of First Editions and their special lure but I associated books with magic. Their totemic qualities aroused me and I believed that to possess them was power. In the difficult years of an evangelical childhood, which is and is not *Oranges are not the only fruit*, I used books as Bram Stoker's Van Helsing uses holy wafers, to mark out a charmed place and to save my soul.

Save my soul from what? From ordinariness, from habit, from prejudice, from fear, from the constraints of a life not chosen by me but strapped onto my back. How to make the burden fall? Through Books. Language caught and made to serve a master. Ariel across time and space.

I trust books, and a wild trust is part of passion. If 'Nature never did betray the heart that loved her' then why should language? Nature was not forbidden to me, and it was through her silent speaking, that I began to understand the physical power of special objects, a power evident in my own library. Books that have the power to move.

Never lie. Never say that something has moved you if you are still in the same place. You can pick up a book but a book can throw you across the room. A book can move you from a comfortable armchair to a rocky place where the sea is. A book can separate you from your husband, your wife,

your children, all that you are. It can heal you out of a lifetime of pain. Books are kinetic, and like all huge forces, need to be handled with care.

But they do need to be handled. The pleasure in a book is, or should be, sensuous as well as aesthetic, visceral as well as intellectual.

There is a book of mine that gives me immediate bodily delight: Twelve woodcuts by Roger Fry, set and printed by Virginia and Leonard Woolf at the Hogarth Press in 1921. One hundred and fifty copies were bound, and because the woodcuts are so lovely, I am sure that many of the copies were broken up and wall-mounted. In her diary entry, Virginia Woolf wrote,

> 150 copies have been gulped down in 2 days. I have
> just finished stitching the last copies – all but 6.

Is it the hand-decorated coloured-paper wrappers, or the thick cream insides, or the fact that she stitched this book that I have before me now? It is association, intrinsic worth, beauty, a commitment to beautiful things, and the deep passage of the woodcuts themselves. Passages into other places. A smuggler's route into what is past and what can never be past.

I hesitated over this book before I bought it from my favourite dealers, Ulysses, by the British Library. It was expensive, and not strictly within the rules of my collection. Book dealers are a wily bunch, and if I needed a final argument, they had it. Unless I bought poor Roger Fry, he was to be sold to the University of Western Australia. I could not do this to an old friend whose art criticism had lit up the

pictures on the wall. I could not condemn Roger Fry to a dry-as-dust-death-in-life glass case across the world. I bought him and I have not for a minute regretted it. That is the way with books. You regret only the ones you did not buy.

Passion. The secret passages matter. Where will the book take you? Like all love-affairs this is an adventure, and it is absurd to be a collector who never reads his collection. There are such people, and in the 1980s damage decade, the investor collector, the poseur-collector and the money-bags bore, did much harm to the true collector, who found that the free market had put expensive locks on what he or she could buy before.

There always have been businessmen who finally found themselves in hand with enough houses, enough boats and cars, to flirt with the arts for a veneer of culture. They buy paintings, and trade among the truly rare book-ends of illuminated manuscripts, but in the 1980s it was James Joyce and Virginia Woolf, Eliot and Wilde that the new-bloated rich began to buy but not to read. Television played its part; the Agent Orange of culture, puff a thing up beyond its measure, and for a time it grows so attractive, so desirable, so fruitful, so lush, and then it collapses, unable to sustain its ridiculous fake growth. Prices for Vita Sackville-West shot up ten-fold over about three years. Fortunately, I had already a copy of *The Land* (1926), inscribed by her and with a rather nice letter on the letterhead of Sissinghurst Castle, inviting a lady to come and view the manuscript of Woolf's

Orlando. I have two signed copies of *Orlando*; the American First Edition which is rather grand on green paper, and the Hogarth Press edition, in its original jacket. Why do I want two? Well, why not?

Vita's prices have come down lately, which means that I might be able to find and afford a copy of *King's Daughter* (1930), with its original wraparound flyer announcing that she had won the Hawthornden Prize for *The Land* (remember 'The greater cats with golden eyes'?).* The award infuriated Virginia Woolf who said that Vita wrote with 'a pen of brass'. Quite often she did and that is why I sometimes turn down her books. I must be able to read and to long to read all that I collect. Well almost all . . .

I was in Bath a few years ago, and as usual popped into a second-hand bookshop. I find the supermarket approach of Waterstones and Smiths a depressing experience, and prefer to support small shops who still care about books as more than commodities. Just as I was leaving, having spent modestly and profited wonderfully, I noticed a privately printed edition of D. H. Lawrence's *Pansies* (pun on pensées), a collection of his more violent, malevolent, and mostly unavailable poems, that seriously jeopardise his free-booting dark-god status. I am an admirer of Lawrence but not an uncritical one, and I know, that like Byron, he attracts men of little brain and lesser balls, who do not want to think

*March 1995. I have bought a copy of *King's Daughter*.

but who are looking for a sign-writer to dress up what they call their sex-drive.

Pansies (1929) is not for them. It is a wonderfully funny book (I think) in which the woes of the world are alternately blamed on 'Willie wet-legs' as Lawrence seems to label all men except himself, and 'lesbians'. One poem begins

> Ego-bound women are always lesbian.

So now we know.

At the front of the book is a brooding drawing of the great man, and underneath, his attractive clear signature. I bought *Pansies* because it was in mint condition and a very good price. I had intended to sell it on to finance some other purchase, but it has amused me so much that I cannot part with it. I am not sure which fate Lawrence would have liked least; to have mouldered so respectably in genteel Bath, or to have been rescued, cheap, by one of those ego-bound women.

By now it will be clear that my collection concentrates itself, 1900–1945 on those Modernists whose work I think vital. That includes major and minor writers of poetry and prose: HD, Marianne Moore, Gertrude Stein, Virginia Woolf, Sitwell, Mansfield, Barney, Radclyffe Hall, Eliot, Graves, Pound and Yeats. I am not overstrict about defining Modernism for the purposes of collecting, and I do buy related material, including, just now, some drawings by

THE PSYCHOMETRY OF BOOKS

Duncan Grant and Vanessa Bell. I would push backwards and buy some Oscar Wilde, and I very nearly did, when a fabulous collection came on the market recently. The trouble is that the collection, being sold via the Talking Bear whom I like, came from a man whom I do not like, and who had made himself a fat fee writing a saucy article about me for a low-rent rag. I suppose that hard-up literary agents must do anything to earn money, but there did seem to me to be a certain amount of irony in the prospect of a man selling available queers to pay the bills. I decided that I would not kindly help to pay any more bills and so, as things stand, I stand without Oscar. But not in spirit.

A collector has to have limits and I would not pay anything for a book I wanted, even if I had limitless wealth. What I try to do is to plough back money from books into books. And not only books. I limit my First Editions so that I can buy art and craft from men and women working now. I see it as a duty as well as a pleasure to use up any disposable income that I have on others, who like me, are in the business of making it new. But I want to maintain my living library. My direct association with those writers without whom . . .

It is a very personal collection. I use daily those books that for others are museumed. The glass case approach depresses me, makes books into porcelain, guts them of what they are. It is not necessary to treat rare books like china. There are only two rules: wash your hands first and put the books away afterwards.

Americans like to keep their First Editions in slip cases,

and my copy of Woolf's *Jacob's Room* came to me in a deep origami puzzle folding binding with a two-inch broad spine of purple leather dressed in gold tooling. If the casual visitor wasn't impressed enough by all that, the tooling announced that the copy was 'autographed'. Ah well, as my American manager often says to me, 'Jeanette, you just have no respect for Celebrity.'

Gertrude Stein would have understood. When T. S. Eliot and his backer Lady Rothermere went to visit Stein in Paris at the rue de Fleurus, Eliot, somewhat sceptical of Stein and her methods, asked, 'Miss Stein, on what authority do you so frequently use the split infinitive?' 'Henry James,' replied Gertrude.

I have collected quite a few of Gertrude's split infinitives, including the *Autobiography of Alice B. Toklas*, signed by both of them. A favourite joke on my library shelves is an edition of Stein's *Wars I have Seen* (1945), which carries as a frontispiece such an entirely terrifying Cecil Beaton portrait of the great lady, that we have retitled her tome, 'Wars I have Seen Off.'

Dear Gertrude, all woman and twice the man. Soon after the *Autobiography* was published, the Left Bank magazine *Transition* printed a refutation of its 'facts', by a string of artists and writers, including Matisse. The injured assumed that if a book calls itself an autobiography it has to be Realist. Not much has changed. I seem to have tethered my own life to a fiction. How dreary it is when a fact is a fact is a fact.

I have a copy of this issue of *Transition* and I was particularly pleased to get it because it belonged to T. S.

Eliot. The book dealer from whom I bought it did not recognise Eliot's handwriting in the annotations, nor perhaps realised that he sometimes just scribbled TOM on his work copies. I knew because the man who introduced me to the vice of book collecting, Simon Nowell Smith, edited Eliot when he reviewed for the *TLS*. Simon Nowell Smith has what I will never have; a Hogarth Press copy of 'Ash Wednesday', set and printed by the Woolfs, hastily bound in their mad wallpaper, and signed 'To Virginia Woolf from T. S. Eliot'.

I do have a signed copy of 'Ash Wednesday', and it was Simon who showed me its typically Eliot joke which I sometimes try at the expense of my guests. 'Ash Wednesday' has far too many front free end-papers, nine in all, before the reader reaches the first line, which is of course,

> Because I do not hope to turn again.

There is at present no twentieth-century poem that means more to me than *Four Quartets*. I know it by heart (Pelmanism is a low-church virtue), and it remains a vital influence on my life and on my work. It moves me, physically, violently, often, and difficultly. Eliot is a difficult poet, not an obscure or unemotional poet, but a writer who demands that every word be charged.

Charge: To load, to put something into, to fill completely, to cause to accumulate electricity, to lay a task

upon, to enjoin, to command, to deliver an official injunction or exhortation. To accuse. To place a bearing upon, to exact or demand from, to ask the price. To attack at a rush; the load of powder. A device born on a shield. The object of care.

All these things each word does, each word is, in his best work. *Four Quartets* is his best work, and for Eliot, work is not a noun, it is a verb. The active poem needs an active reader.

I have the individual pamphlets, as they were first issued by Faber over a period of eight years, and I have the collected poem, inscribed by Eliot to Maurice Haigh-Wood, the brother of his first wife, Vivien.

The psychometry of books. At the risk of sounding like Madame Blavatsky, the mystic friend of mystic Yeats, I can confirm that signed First Editions offer a presence not found in any old book and never found in paperbacks.

Strictly speaking, psychometry is the occult power of divining the properties of things by mere contact. I do not recommend it as an alternative to reading but it is an exciting supplement. It is worth remembering that in the past any print-run of a book you love is likely to have been a very small print-run, and that those copies signed will be few.

I know that Edith Sitwell signed everything, including other people's books, but I am still glad to have her personal copy of *Façade* (1923).

It may be that the intensity of the moment, and the attitude of a time when books were not blasé, has fixed itself

into the cover and the pages and is only gently decayed by time. Books have isotopic qualities and the excitement a collector feels is not simply biographical, archival, historical, it is emotional. Emotion calls to emotion. A strange meeting of feeling that will not submit to ordinary analysis.

I confess that there is in my book hunts and book passions something pretty close to hoarding the hair of martyrs and the sweat of saints. My books are a private altar. They are a source of strength and a place of worship. I see no reason to refuse to bend the knee. What woman writer writing now can pass by *A Room of One's Own* (1929)? But for me, when I read my copy signed in purple ink, there is an extra power. Here she is and here she was, of private ancestors, the most complete.

When I had no books and had to learn everything I needed off by heart, and when I had to hide what books I had, I promised myself a library filled with the best editions I could afford. I have it now. Books bought out of books. A red room with deep chairs and a fireplace lit. Books of every kind, but no paperbacks, and certain shelves where the First Editions are. This is not my study, where there are plenty of paperbacks, it is a contemplative island cut off from busyness, set outside of time.

Close the shutters and turn up the lamp. The room is full of voices. Who are they that shine in gold like apostles in a church window at midday? There is more in my hands than

a book. Pick it up, and the streets empty of traffic, the place is still. The movement is an imaginative one, the secret passage between body and book, the connections known only to you. Intimate illuminations when the reader and what is read are both unaware of the hands of the clock.

The clock is ticking. Let it. In your hands, a book that was in their hands, passed to you across the negligible years of time. Art is indifferent to time, and if you want proof, you have it. Pick up the book. It is still warm.

IMAGINATION
AND REALITY

The reality of art is the reality of the imagination.

What do I mean by reality of art?

What do I mean by reality of imagination?

My statement, and the questions it suggests, are worth considering now that the fashionable approach to the arts is once again through the narrow gate of subjective experience. The charge laid on the artist, and in particular on the writer, is not to bring back visions but to play the Court photographer.

Is this anathema to art? Is it anti-art? I think so. What art presents is much more than the daily life of you and me, and the original role of the artist as visionary is the correct one.

'Real' is an old word, is an odd word. It used to mean a Spanish sixpence; a small silver coin, money of account in the days when the value of a coin was the value of its metal. We are used to notional money but 'real' is an honest currency.

The honest currency of art is the honest currency of the imagination.

The small silver coin of art cannot be spent; that is, it cannot be exchanged or exhausted. What is lost, what is destroyed, what is tarnished, what is misappropriated, is ceaselessly renewed by the mining, shaping, forging imagination that exists beyond the conjectures of the everyday. Imagination's coin, the infinitely flexible metal of the Muse, metal of the moon, in rounded structure offers new universes, primary worlds, that substantially confront the pretences of notional life.

Notional life is the life encouraged by governments, mass education and the mass media. Each of those powerful agencies couples an assumption of its own importance with a disregard for individuality. Freedom of choice is the catch phrase but streamlined homogeneity is the objective. A people who think for themselves are hard to control and what is worse, in a money culture, they may be sceptical of product advertising. Since our economy is now a consumer economy, we must be credulous and passive. We must believe that we want to earn money to buy things we don't

need. The education system is not designed to turn out thoughtful individualists, it is there to get us to work. When we come home exhausted from the inanities of our jobs we can relax in front of the inanities of the TV screen. This pattern, punctuated by birth, death and marriage and a new car, is offered to us as real life.

Children who are born into a tired world as batteries of new energy are plugged into the system as soon as possible and gradually drained away. At the time when they become adult and conscious they are already depleted and prepared to accept a world of shadows. Those who have kept their spirit find it hard to nourish it and between the ages of twenty and thirty, many are successfully emptied of all resistance. I do not think it an exaggeration to say that most of the energy of most of the people is being diverted into a system which destroys them. Money is no antidote. If the imaginative life is to be renewed it needs its own coin.

We have to admit that the arts stimulate and satisfy a part of our nature that would otherwise be left untouched and that the emotions art arouses in us are of a different order to those aroused by experience of any other kind.

We think we live in a world of sense-experience and what we can touch and feel, see and hear, is the sum of our reality. Although neither physics nor philosophy accepts this, neither physics nor philosophy has been as successful as religion used to be at persuading us of the doubtfulness of the seeming-solid world. This is a pity if only because while religion was a matter of course, the awareness of other

realities was also a matter of course. To accept God was to accept Otherness, and while this did not make the life of the artist any easier (the life of the artist is never easy), a general agreement that there is more around us than the mundane allows the artist a greater licence and a greater authority than he or she can expect in a society that recognises nothing but itself.

An example of this is the development of the visual arts under Church patronage during the late medieval and Renaissance periods in Europe. This was much more than a patronage of money, it was a warrant to bring back visions. Far from being restricted by Church rhetoric, the artist knew that he and his audience were in tacit agreement; each went in search of the Sublime.

Art is visionary; it sees beyond the view from the window, even though the window is its frame. This is why the arts fare much better alongside religion than alongside either capitalism or communism. The god-instinct and the art-instinct both apprehend more than the physical biological material world. The artist need not believe in God, but the artist does consider reality as multiple and complex. If the audience accepts this premise it is then possible to think about the work itself. As things stand now, too much criticism of the arts concerns itself with attacking any suggestion of art as Other, as a bringer of realities beyond the commonplace. Dimly, we know we need those other realities and we think we can get them by ransacking different cultures and rhapsodising work by foreign writers simply because they are foreign writers. We are still back with art as the mirror of life, only it is a more exotic or less

democratic life than our own. No doubt this has its interests but if we are honest, they are documentary. Art is not documentary. It may incidentally serve that function in its own way but its true effort is to open to us dimensions of the spirit and of the self that normally lie smothered under the weight of living.

It is in Victorian England that the artist first becomes a rather suspect type who does not bring visions but narcotics and whose relationship to different levels of reality is not authoritative but hallucinatory. In Britain, the nineteenth century recovered from the shock of Romanticism by adopting either a manly Hellenism, with an interest in all things virile and Greek, or a manly philistinism, which had done with sweet Jonney Keats and his band and demanded of the poet, if he must be a poet, that he be either declamatory or decorative. Art could be rousing or it could be entertaining. If it hinted at deeper mysteries it was effeminate and absurd. The shift in sensibility from early to late Wordsworth is the shift of the age. For Tennyson, who published his first collection in 1830, the shift was a painful one and the compromises he made to his own work are clear to anyone who flicks through the collected poems and finds a visionary poet trying to hide himself in legend in order to hint at sublimities not allowed to his own time. Like Wordsworth before him, Tennyson fails whenever he collapses into the single obsessive reality of the world about him. As a laureate we know he is lying. As a visionary we read him now and find him true.

And what are we but our fathers' sons and daughters? We are the Victorian legacy. Our materialism, our lack of

spirituality, our grossness, our mockery of art, our utilitarian attitude to education, even the dull grey suits wrapped around the dull grey lives of our eminent City men, are Victorian hand-me-downs. Many of our ideas of history and society go back no further than Victorian England. We live in a money culture because they did. Control by plutocracy is a nineteenth-century phenomenon that has been sold to us as a blueprint for reality. But what is real about the values of a money culture?

Money culture recognises no currency but its own. Whatever is not money, whatever is not making money, is useless to it. The entire efforts of our government as directed through our society are efforts towards making more and more money. This favours the survival of the dullest. This favours those who prefer to live in a notional reality where goods are worth more than time and where things are more important than ideas.

For the artist, any artist, poet, painter, musician, time in plenty and an abundance of ideas are the necessary basics of creativity. By dreaming and idleness and then by intense self-discipline does the artist live. The artist cannot perform between 9 and 6, five days a week, or if she sometimes does, she cannot guarantee to do so. Money culture hates that. It must know what it is getting, when it is getting it, and how much it will cost. The most tyrannical of patrons never demanded from their protegées what the market now demands of artists; if you can't sell your work regularly and quickly, you can either starve or do something else. The time that art needs, which may not be a long time, but which

has to be its own time, is anathema to a money culture. Money confuses time with itself. That is part of its unreality.

Against this golden calf in the wilderness where all come to buy and sell, the honest currency of art offers quite a different rate of exchange. The artist does not turn time into money, the artist turns time into energy, time into intensity, time into vision. The exchange that art offers is an exchange in kind; energy for energy, intensity for intensity, vision for vision. This is seductive and threatening. Can we make the return? Do we want to? Our increasingly passive diversions do not equip us, mentally, emotionally, for the demands that art makes. We know we are dissatisfied, but the satisfactions that we seek come at a price beyond the resources of a money culture. Can we afford to live imaginatively, contemplatively? Why have we submitted to a society that tries to make imagination a privilege when to each of us it comes as a birthright?

It is not a question of the money in your pocket. Money can buy you the painting or the book or the opera seat but it cannot expose you to the vast energies you will find there. Often it will shield you from them, just as a rich man can buy himself a woman but not her love. Love is reciprocity and so is art. Either you abandon yourself to another world that you say you seek or you find ways to resist it. Most of us are art-resisters because art is a challenge to the notional life. In a money culture, art, by its nature, objects. It fields its own realities, lives by its own currency, aloof to riches and want. Art is dangerous.

FOR SALE: MY LIFE. HIGHEST BIDDER COLLECTS.

The honest currency of art is the honest currency of the imagination.

In Middle English, 'real' was a variant of 'royal'.

Can we set aside images of our own dishonoured monarchy and think instead about the ancientness and complexity of the word 'royal'?

To be royal was to be distinguished in the proper sense; to be singled out, by one's fellows and by God or the gods. In both the Greek and the Hebraic traditions, the one who is royal is the one who has special access to the invisible world. Ulysses can talk to Hera, King David can talk to God. Royalty on earth is expected to take its duties on earth seriously but the King should also be a bridge between the terrestrial and the supernatural.

Perhaps it seems strange to us that in the ancient world the King was more accessible to his people than were the priests. Although King and priest worked together, priesthood, still allied to magic, even by the Hebrews, was fully mysterious. The set-apartness of the priest is one surrounded by ritual and taboo. The priest did not fight in battle, take concu-bines, hoard treasure, feast and riot, sin out of humanness, or if he did, there were severe penalties. The morality of the priesthood was not the morality of Kingship and whether you read *The Odyssey* or The Bible, the difference is striking.

The King is not better behaved than his subjects, essentially he was (or should have been) the nobler man.

In Britain, royalty was not allied to morality until the reign of Queen Victoria. Historically, the role of the King or Queen had been to lead and inspire, this is an imaginative role, and it was most perfectly fulfilled by Elizabeth the First, Gloriana, the approachable face of Godhead. Gloriana is the Queen whose otherness is for the sake of her people, and it is important to remember that the disciplines she laid upon her own life, in particular her chastity, were not for the sake of example but for the sake of expediency. The Divine Right of Kings was not a good conduct award it was a mark of favour. God's regent upon earth was expected to behave like God and anyone who studies Greek or Hebrew literature will find that God does not behave like a Christian schoolmistress. God is glorious, terrifying, inscrutable, often capricious to human eyes, extravagant, victorious, legislative but not law-abiding, and, the supreme imagination. 'In the beginning was the Word.'

At its simplest and at its best, royalty is an imaginative function; it must embody in its own person, subtle and difficult concepts of Otherness. The priest does not embody these concepts, the priest serves them. The priest is a functionary, the King is a function.

Shakespeare is preoccupied with Kingship as a metaphor for the imaginative life. Leontes and Lear, Macbeth and Richard II, are studies in the failure of the imagination. In *The Winter's Tale*, the redemption of Leontes is made possible

through a new capacity in him; the capacity to see outside of his own dead vision into a chance as vibrant as it is unlikely. When Paulina says to him, 'It is required you do awake your faith' she does not mean religious faith. If the statue of Hermione is to come to life, Leontes must believe it *can* come to life. This is not common sense. It is imagination.

In the earliest Hebrew creation stories Yahweh makes himself a clay model of a man and breathes on it to give it life. It is this supreme confidence, this translation of forms, the capacity to recognise in one thing the potential of another, and the willingness to let that potential realise itself, that is the stamp of creativity and the birthright that Yahweh gives to humans. Leontes' failure to acknowledge any reality other than his own is a repudiation of that birthright, a neglect of humanness that outworks itself into the fixed immobility of his queen. When Hermione steps down and embraces Leontes it is an imaginative reconciliation.

I hope it is clear that as I talk about King and priest I am dealing in abstracts and not actualities. I do not wish to upset republicans anywhere. What I do want to do is to move the pieces across the chessboard to see if that gives us a different view.

By unravelling the word 'real' I hope to show that it contains in itself, and without any wishful thinking on my part, those densities of imaginative experience that belong to us all and that are best communicated through art. I see no conflict between reality and imagination. They are not in fact separate. Our real lives hold within them our royal lives;

the inspiration to be more than we are, to find new solutions, to live beyond the moment. Art helps us to do this because it fuses together temporal and perpetual realities.

To see outside of a dead vision is not an optical illusion.

The realist (from the Latin *res* = thing) who thinks he deals in things and not images and who is suspicious of the abstract and of art, is not the practical man but a man caught in a fantasy of his own unmaking.

The realist unmakes the coherent multiple world into a collection of random objects. He thinks of reality as that which has an objective existence, but understands no more about objective existence than that which he can touch and feel, sell and buy. A lover of objects and of objectivity, he is in fact caught in a world of symbols and symbolism, where he is unable to see the thing in itself, as it really is, he sees it only in relation to his own story of the world.

The habit of human beings is to see things subjectively or not to see them at all. The more familiar a thing becomes the less it is seen. In the home, nobody looks at the furniture, they sit on it, eat off it, sleep on it and forget it until they buy something new. When we do look at other people's things, we are usually thinking about their cachet, their value, what they say about their owner. Our minds work to continually label and absorb what we see and to fit it neatly into our own pattern. That done, we turn away. This is a sound survival skill but it makes it very difficult to let anything have an existence independent of ourselves, whether furniture or

people. It makes it easier to buy symbols, things that have a particular value to us, than it does to buy objects.

My mother, who was poor, never bought objects, she bought symbols. She used to save up to buy something hideous to put in the best parlour. What she bought was factory made and beyond her purse. If she had ever been able to see it in its own right, she could never have spent money on it. She couldn't see it, and nor could any of the neighbours dragged in to admire it. They admired the effort it had taken to save for it. They admired how much it cost. Above all, they admired my mother; the purchase was a success.

I know that when my mother sat in her kitchen that had only a few pieces of handmade furniture, she felt depressed and conscious of her lowly social status. When she sat in her dreadful parlour with a china cup and a bought biscuit, she felt like a lady. The parlour, full of objects unseen but hard won, was a fantasy chamber, a reflecting mirror. Like Mrs Joe, in *Great Expectations*, she finally took her apron off.

Money culture depends on symbolic reality. It depends on a confusion between the object and what the object represents. To keep you and me buying and upgrading an overstock of meaningless things depends on those things having an acquisitional value. It is the act of buying that is important. In our society, people who cannot buy things are the underclass.

Symbolic man surrounds himself with objects as tyrants surround themselves with subjects: 'These will obey me. Through them I am worshipped. Through them I exercise control.' These fraudulent kingdoms, hard-headed and

practical, are really the soft-centre of fantasy. They are wish fulfilment nightmares where more is piled on more to manufacture the illusion of abundance. They are lands of emptiness and want. Things do not satisfy. In part they fail to satisfy because their symbolic value changes so regularly and what brought whistles of admiration one year is next year's car boot sale bargain. In part they fail to satisfy because much of what we buy is gadgetry and fashion, which makes objects temporary and the need to be able to purchase them, permanent. In part they fail to satisfy because we do not actually want the things we buy. They are illusion, narcotic, hallucination.

To suggest that the writer, the painter, the musician, is the one out of touch with the real world is a doubtful proposition. It is the artist who must apprehend things fully, in their own right, communicating them not as symbols but as living realities with the power to move.

To see outside of a dead vision is not an optical illusion.

According to the science of optics, if an image consists of points through which light actually passes, it is called real. Otherwise it is called virtual.

The work of the artist is to see into the life of things; to discriminate between superficialities and realities; to know what is genuine and what is a make-believe. The artist through the disciplines of her work, is one of the few people

who does see things as they really are, stripped of associative value. I do not mean that artists of whatever sort have perfect taste or perfect private lives, I mean that when the imaginative capacity is highly developed, it is made up of invention and discernment. Invention is the shaping spirit that re-forms fragments into new wholes, so that even what has been familiar can be seen fresh. Discernment is to know how to test the true and the false and to reveal objects, emotions, ideas in their own coherence. The artist is a translator; one who has learned how to pass into her own language the languages gathered from stones, from birds, from dreams, from the body, from the material world, from the invisible world, from sex, from death, from love. A different language is a different reality; what is the language, the world, of stones? What is the language, the world, of birds? Of atoms? Of microbes? Of colours? Of air? The material world is closed to those who think of it only as a commodity market.

> How do you know but every bird that cuts the airy way
> Is an immense world of delight closed by your senses five?

> William Blake, *The Marriage of Heaven and Hell* (*c*. 1790)

To those people every object is inanimate. In fact they are the ones who remain unmoved, fixed rigidly within their own reality.

The artist is moved.

The artist is moved through multiple realities. The artist is moved by empty space and points of light. The artist tests the image. Does light pass through it? Is it illuminated? Is it sharp, clear, its own edges, its own form?

The artist is looking for real presences. I suppose what the scientist Rupert Sheldrake would call 'morphic resonance'; the inner life of the thing that cannot be explained away biologically, chemically, physically. In the Catholic Church 'real presence' is the bread and wine that through transubstantiation becomes the living eucharist; the body and blood of Christ. In the Protestant Church the bread and wine are symbols only, one of the few places where we recognise that we are asking one thing to substitute for another. For the average person, this substitution is happening all the time.

The real presence, the image transformed by light, is not rare but it is easily lost or mistaken under clouds of subjectivity. People who claim to like pictures and books will often only respond to those pictures and books in which they can clearly find themselves. This is ego masquerading as taste. To recognise the worth of a thing is more than recognising its worth to you. Our responses to art are conditioned by our insistence that it present to us realities we can readily accept, however virtual those realities might be. Nevertheless art has a stubborn way of cutting through the subjective world of symbols and money and offering itself as a steady alternative to the quick change act of daily life.

We are naturally suspicious of faculties that we do not ourselves possess and we do not quite believe that the poet can read the sermons in stones or the painter know the purple that bees love. Still we are drawn to books and

pictures and music, finding in ourselves an echo of their song, finding in ourselves an echo of their sensibility, an answering voice through the racket of the day.

Art is for us a reality beyond now. An imaginative reality that we need. The reality of art is the reality of the imagination.

The reality of art is not the reality of experience.

The charge laid on the artist is to bring back visions.

In Shakespeare's *Othello*, we find that the Moor wins Desdemona's heart by first winning her imagination. He tells her tales of cannibals and of the Anthropophagi whose heads grow beneath their shoulders. What he calls his 'round unvarnished tale' is a subtle mixture of art and artfulness. When a Shakespearean hero apologises for his lack of wit we should be on our guard. Shakespeare always gives his heroes the best lines, even when the hero is Richard II.

Othello's untutored language is in fact powerful and wrought. He is more than a master of arms, he is a master of art. It is his words that win Desdemona. She says 'I saw Othello's visage in his mind.' His face, like his deeds, belongs to the world of sense-experience, but it is his wit that makes both dear to her. For Desdemona, the reality of Othello is his imaginative reality.

OTHELLO she thank'd me,
 And bade me, if I had a friend that lov'd
 her,
 I should but teach him how to tell my story,
 And that would woo her.

The clue here is not the story but the telling of it. It is not Othello the action man who has taught Desdemona to love him, it is Othello the poet.

We know that Shakespeare never bothered to think of a plot. As a good dramatist and one who earned his whole living by his work, he had to take care to make his historical ransackings stage-satisfactory. The engineering of the plays gives pleasure even to those who are not interested in the words. But the words are the thing. The words are what interested Shakespeare and what should closely interest us. Shakespeare is a dramatic poet. He is not a chronicler of experience.

I have to say something so obvious because of the multitude of so called realists, many making money out of print, who want art to be as small as they are. For them, art is a copying machine busily copying themselves. They like the documentary version, the 'life as it is lived'. To support their opinions they will either point to Dickens or Shakespeare. I have never understood why anyone calls Dickens a realist, but I have dealt with that myth elsewhere in these essays. As for Shakespeare, they will happily disregard the pervading spirit behind the later plays, and quote *Hamlet* Act III, Scene II 'the purpose of playing . . . is, to hold, as 'twere, the mirror up to nature.'

But what is nature?

From the Latin *Natura*, it is my birth, my characteristics, my condition.

It is my nativity, my astrology, my biology, my physiognomy, my geography, my cartography, my spirituality, my sexuality, my mentality, my corporeal, intellectual, emotional, imaginative self. And not just my self, every self and the Self of the world. There is no mirror I know that can show me all of these singularities, unless it is the strange distorting looking-glass of art where I will not find my reflection nor my representation but a nearer truth than I prefer. *Natura* is the whole that I am. The multiple reality of my existence.

The reality of the imagination leaves out nothing. It is the most complete reality that we can know. Imagination takes in the world of sense experience, and rather than trading it for a world of symbols, delights in it for what it is. The artist is physical and it is in the work of true artists in any medium, that we find the most moving and the most poignant studies of the world that we can touch and feel. It is the writer, the painter, and not the realist, who is intimate with the material world, who knows its smells and tastes because they are fresh in her nostrils, full in her mouth. What her hand touches, she feels. R. A. Collingwood said that Cézanne painted like a blind man (critics at the time agreed though for different reasons). He meant that the two-dimensional flimsy world of what is overlooked by most of us, suddenly reared out of the canvas, massy and tough. Cézanne seems to have hands in his eyes and eyes in his hands. When Cézanne paints a tree or an apple, he does not paint a copy of a tree or an apple, he

paints its nature. He paints the whole that it is, the whole that is lost to us as we pass it, eat it, chop it down. It is through the painter, writer, composer, who lives more intensely than the rest of us, that we can rediscover the intensity of the physical world.

And not only the physical world. There is no limit to new territory. The gate is open. Whether or not we go through is up to us, but to stand mockingly on the threshold, claiming that nothing lies beyond, is something of a flat earth theory.

The earth is not flat and neither is reality. Reality is continuous, multiple, simultaneous, complex, abundant and partly invisible. The imagination alone can fathom this and it reveals its fathomings through art.

The reality of art is the reality of the imagination.

ART & LIFE

I grew up not knowing that language was for everyday purposes. I grew up with the Word and the Word was God. Now, many years after a secular Reformation, I still think of language as something holy.

My parents owned six books between them. Two of those were Bibles and the third was a concordance to the Old and New Testaments. The fourth was *The House At Pooh Corner*. The fifth, *The Chatterbox Annual 1923* and the sixth, Malory's *Morte d'Arthur*.

I found it necessary to smuggle books in and out of the house and I cannot claim too much for the provision of an outside toilet when there is no room of one's own. It was on the toilet that I first read Freud and D. H. Lawrence, and perhaps that was the best place, after all. We kept a rubber torch hung on the cistern, and I had to divide my money from a Saturday job, between buying books and buying batteries. My mother knew exactly how long her Evereadys would last if used only to illuminate

the gap that separated the toilet paper from its function.

Once I had tucked the book back down my knickers to get it indoors again, I had to find somewhere to hide it, and anyone with a single bed, standard size, and paperbacks, standard size, will discover that seventy-seven can be accommodated per layer under the mattress. But as my collection grew, I began to worry that my mother might notice that her daughter's bed was rising visibly. One day she did. She burned everything.

Not everything. I had started to shift my hoard to a friend's house and I still have some of those early books, faithfully bound in plastic, none of their spines broken.

My fortunes improved when my mother approved a job for me at the Public Library. She reckoned that I would be unable to read and work at the same time and that she would benefit from unlimited supplies of large print mysteries. I think too, that she hoped that simply being around books would cure me of my obsession for them, rather in the way that retired astronauts are advised to lie and look at the stars. In practice, I went to the library even when I was not working, and sat uninterrupted in the Reading Room, under a stained-glass window that told me that 'Industry and Prudence Conquer'.

Weekly sackfuls of *Ellery Queen* seemed to have a sedating effect on my mother. My father continued with *The Beano*. At the library, dutifully stamping out wave upon

wave of sea stories, and the battered blossoms of Mills and Boon, I realised what I had known dimly; that plot was meaningless to me. This was a difficult admission for one whose body was tattooed with Bible stories, but I had to accept that my love-affair was with language, and only incidentally with narrative.

Mulling over my new freedom from the gross weight of how to get from A to B, I came across Gertrude Stein in the Humour section. I do not know why she had been branded with a purple giggle-strip and heaped unalphabetically alongside Alan Coren. Our system in the library was not to alphabetise popular genres, on the grounds that if you want a Western you want one, and the gun is mightier than the pen-name. I had noticed Stein kept being taken out one day, and returned the next, and when I borrowed her myself I realised why. I returned her to her rightful place, under S, in the literature section. Only one man complained that he could no longer find 'those nonsense books by Steen'. He was a vet.

What will happen when there are no more Public Libraries and the world is on CD-Rom? Where will we go, we exiles from actuality? What will happen to vets who read Miss Steen and young girls looking for visions beyond their allotted lens? In the homogeneity of screen and disc who will find the disruptiveness of the page? And will we invent fabulous stories of lost libraries where rooked urchins gather books from mile high branches of crazy shelves?

As I was about to embark on two years undisturbed with the poets, I was disturbed, and by my mother, in the Reading Room. She had found out about my secret life and come to have a showdown by the photocopier. She said 'The trouble with books is that you don't know what's in them until it is too late.'

I challenged her with her own taste in murder mysteries and received the reply that if you are expecting a murder it isn't a shock. This helped my theories on plot but it didn't help my position by the photocopier. My mother knew that books would lead me astray and she was right. A short time later I left home. I took nothing with me; the things I loved had already gone.

I wake and sleep language. It has always been so. I had been brought up to memorise very long Bible passages, and when I left home and was supporting myself so that I could continue my education, I fought off loneliness and fear by reciting. In the funeral parlour I whispered Donne to the embalming fluids and Marvell to the corpses. Later, I found that Tennyson's 'Lady of Shalott' had a soothing, because rhythmic, effect on the mentally disturbed. Among the disturbed I numbered myself at that time.

The healing power of art is not a rhetorical fantasy. Fighting to keep language, language became my sanity and my strength. It still is, and I know of no pain that art cannot assuage. For some, music, for some, pictures, for me,

primarily, poetry, whether found in poems or in prose, cuts through noise and hurt, opens the wound to clean it, and then gradually teaches it to heal itself. Wounds need to be taught to heal themselves.

The psyche and the spirit do not share the instinct of the damaged body. Healing is not automatically triggered nor is danger usually avoided. Since we put ourselves in the way of hurt it seems logical to put ourselves in the way of healing. Art has more work to do than ever before but it can do that work. In a self-destructive society like our own, it is unsurprising that art as a healing force is despised.

For myself, when I returned to my borrowed room night after night, and there were my books, I felt relief and exuberance, not hardship and exhaustion. I intended to avoid the fate of *Jude the Obscure*, although a reading of that book was a useful warning. What I wanted did not belong to me by right and whilst it could not be refused to me in quite the same way, we still have subtle punishments for anyone who insists on what they are and what they want. Walled inside the little space marked out for me by family and class, it was the limitless world of the imagination that made it possible for me to scale the sheer face of other people's assumptions. Inside books there is perfect space and it is that space which allows the reader to escape from the problems of gravity.

In 1978 I packed all of my wordly goods into the back of my Morris Minor van and drove to Oxford. For the first few weeks I suspected that I had been dropped into the middle of a special practical joke. Not only did everybody read books, they were expected to read books, and given money to read books. Did I really not have to prepare my essay in the toilet?

I spent three years doing what modern governments more and more want to stop students doing; reading widely and thinking for themselves. The move towards intensively taught shorter courses will help to produce passive, materially minded young people who believe that everything is a means to an end, but who illogically therefore, do not believe in an after-life. If this is the only life we have, then it had better be an end itself hadn't it?

The worst nineteenth-century drudge could at least depend on eternal life. The twentieth-century robot depends on lasting until retirement.

I like to live slowly. Modern life is too fast for me. That may be because I was brought up without the go-faster gadgets of science, and now that I can afford them, see no virtues in filling the day with car rides, plane rides, mobile phones, computer communication.

If you deal in real things, those things have a pace of their own that haste cannot impose upon. The garden I cultivate, the vegetables I grow, the wood I have to chop, the coal I have to fetch, the way I cook, (casseroles), the way I shop, (little and often), the time it takes to read a book, to listen to music, the time it takes to write a book, none of

those things can happen in microwave moments. I am told that the values I hold and the way I live are anachronisms paid for by privilege. It is a privilege to make books that people want to read but why would it be more appropriate, less anachronistic, for me to spend the money I earn on a flashy lifestyle instead of funding my own peace and quiet?

One of the casualties of progress is peace and quiet. My great-grandparents, who worked a twelve-hour day in a Lancashire cotton mill, could at least walk to the Heights behind their cottage, and find silence under their feet and a long view of hills. I was able to escape the crash of evangelical fervour and hide in those same hills at the top of our street where stone gave way to grass and the sound was the sound of the wind. Those hills have taken a relief road through their belly now; not a cut and cover, too expensive, and who cares about hills when you could have cars? The factory workers have stereos and satellite TV, and what they once got out of silence they can now get out of noise. Yes? No?

Silence and noise do not seem to me to be equivalents. When I was growing up, without a bathroom, without a car, without a telephone, without central heating, without a record player, without money, silence was free and not far away. Now it is a marketable commodity and more expensive than a good seat at Covent Garden.

When I was growing up, the noisiest noise I ever heard was a tambourine and a male voice choir. This may explain

why I love women and dislike Verdi operas. It was certainly a factor in my recent decision to leave London.

I do not mean that London has become a focus for hymn-singing testosterones and their tinkly wives, I mean that I cannot afford to live in a place that cannot afford silence.

How shall I live?

When I wrote *Art & Lies*, I said it was a question and a quest. Handel, Picasso, Sappho, each fleeing a dead city, and a life they can no longer bear. The dead city is a London of the future, a potential place without values. I do not think it possible (or moral) to write a book that is made to affect others without being affected oneself. I did not put my life into *Art & Lies*, as people commonly understand the artist at work, but I have put *Art & Lies* into my life. The question 'How shall I live?' had to be addressed to myself.

Books push their writer forward. The writer has to have ready the accumulation of what she is, at the point of the book, but the book, itself, will prove more than its writer. The act of writing, itself, is an evolution; from the Latin, *Volvere, volvi, volutum*, to roll. The unrolling of the secret scroll, the thing suspected but not realised until present. The being-book gives off heat and urges out of the writer new ideas, new imaginations, previously inchoate. This sense of complicity, the working together of writer and word is a process more confident and more obvious the more the

writer learns to trust what it is she does. For tightrope walkers everywhere, trustfulness of the rope is a certainty that comes out of discipline, to others it is just a rope. To you it is life-line and communication cord. To walk it to its end, and disappear, rewards the unseen hours in the dust.

The rope is hand produced; the writer makes it as she walks it, just as, in *Sexing the Cherry*, Fortunata escapes the house that celebrates ceilings but denies floors, by cutting and retying the rope as she descends. Impossible? Certainly, but art is impossible. There is no biological reason for it to exist, no laboratories specially funded to carry on its experiments, no particular approval from the world at large, no education that can guarantee its being, no common consent that it matters, not much money, and even those who do well do never so well as dross merchants or professional footballers. And yet . . . Is it because human beings are tantalised by the impossible or is it that even the late twentieth century cannot quite believe that its real life is in silicon chips and stocks and shares?

To live for art (*Vissi d'arte, vissi d'amore*, as Callas sings in Puccini's *Tosca*), is to live a life of questioning. And if you believe, as I do, that to live for art demands that every other part of life be moved towards one end, then the question 'How shall I live?' is fierce. The choices I am making are choices that allow me to go on working at maximum output and with utmost concentration. If my partner needed to live on the coast for her health's sake, no-one would be surprised that I should go. Should there be any surprise that I am returning to a quieter existence for the sake of my work?

Quieter than what? I do not go out except to the opera and to the local shops. I never accept party invitations although I do send them. My day is simple: Get up, light the fire, and while it and my thoughts are catching, grind the coffee and have a wash. I have to admit that I dislike baths, probably as a result of never having had one until I was fourteen. I would not like the reader to assume that I smell. I am fastidious if unbathed. It troubles me very little to live without conveniences, although my partner does insist on an inside toilet.

I remember a journalist calling once, and remarking on the blazing fire in the red library. 'Is that for effect?' she said. I told her that in England one has to keep warm somehow and she asked why I couldn't afford what she called 'real heat'. Although there are clear differences between myself and D. H. Lawrence, I share with him the suspicion that there is something immoral about central heating. The surest way to put Lawrence into a rage was to sit him by a radiator, and Richard Aldington tells of how Lawrence often preferred to lurk in the hall than subject his virility to anonymous heat. I have been lighting my own fire since I was a tiny girl and I hope to do so on the day that I die. There is no comfort to be had from a radiator and no-one I recall has yet had a vision while staring into the white enamel.

Comfort and visions. The solace of the fire is an ancient one and evolution is a very slow process. I do not want to live in exile from my evolutionary environment; the land, the seasons, other creatures, and certain rituals; paper and twigs, and on my knees as generations before me, and the same pleasure felt at the first flames.

There are people who tell me that I am cut off but to what are they connected?

My connections are to the earth under my feet and the words that fill both hands. And not hands only, mouth, liver, gut, bowel, mind, blood, cunt.

> Moreover, if you consider any great figure of the past, like Sappho, like the Lady Murasaki, like Emily Brontë, you will find that she is an inheritor as well as an originator, and has come into existence because women have come to have the habit of writing naturally; so that even as a prelude to poetry such activity on your part would be invaluable . . .

> For my belief is that if we live another century or so – I am talking of the common life which is the real life and not of the little separate lives which we live as individuals – and have five hundred a year each of us and rooms of our own; if we have the habit of freedom and the courage to write exactly what we think; if we escape a little from the common sitting-room and see human beings not always in their relation to each other but in relation to reality; and the sky, too, and the trees or whatever it may be in themselves; if we look past Milton's bogy, for no human being should shut out the view; if we face the fact, for it is a fact, that there is no arm to cling to, but that we go alone and that our relation is to the world of reality and not only to the world of men and women, then the opportunity will come and the dead poet who was Shakespeare's sister will put on the body which she has so often laid down. Drawing her life from the lives of the unknown who were her forerunners, as

her brother did before her, she will be born. As for her coming without that preparation, without that effort on our part, without that determination that when she is born again she shall find it possible to live and write her poetry, that we cannot expect, for that would be impossible. But I maintain that she would come if we worked for her, and that so to work, even in poverty and obscurity, is worth while.

Virginia Woolf, *A Room of One's Own* (1928)

That is where I am in history.

A WORK OF MY OWN

To talk about my own work is difficult. If I must talk about it at all I would rather come at it sideways, through the work of writers I admire, through broader ideas about poetry and fiction and their place in the world.

It is a strange time; the writer is expected to be able to explain his or her work as though it were a perplexing machine supplied without an instruction manual. The question 'What is your book about?' has always puzzled me. It is about itself and if I could condense it into other words I should not have taken such care to choose the words I did. In any case, if a finished piece of work is inadequate without copious footnotes from the author, it is inadequate. I have tried to make it clear, in these essays and elsewhere, that the language of literature is not an approximate language. It is the most precise language that human beings have yet developed. The spaces it allows are not formless vistas of subjectivity, they are new territories of imagination. Unlike the language of mathematics (which I

admit is beautiful), the language of literature need not be pared of emotion and association to avoid error. Human beings cannot avoid error, even the purest mathematician would accept that, and wild readings of strong texts are no commoner than the wild inferences of science. We are a speculative, subjective, changing people and each new generation considers itself more enlightened than its predecessor; a view that science both encourages and depends on. Literature (all art) takes a different view; human nature, emotional reality is not seen as a progress from darkness to light but as a communication, with ourselves and across time, so that work entirely out of date by scientific standards is as fresh and meaningful to us as it ever was. Whereas science outdates the past art keeps it present. Whereas the language of science tries to eliminate error, chiefly by the use of agreed symbols carrying an agreed value, the language of literature seems to be able to contain error by being greater than it. For instance, Shakespeare has not been sunk by the weight of four hundred years of scholarly and popular interpretations, and we do not much mind if we see a poor production of our favourite play because we know that very soon we shall see a good one, perhaps even one which takes us closer into the core than we thought possible. And what is the core? Nobody will agree, there is no such thing as an agreed value Shakespeare. This is not because Shakespeare is less precise than a mathematical equation it is because he is unfixed. Language is movement, and I do not only mean inevitable development or deterioration, I mean that words are fleet-footed things and when right run, escape us at the place where we think we have wrestled them flat.

All good writers aspire towards such precision and movement, and the experiments that writers must make are for the sake of new frequencies of language which in turn allow new frequencies of emotion. The writer has to choose a word, every word, that is solid enough for its meaning and powered enough for its flight. The word will have to cross time, the word will have to survive assault. At certain stages of its history, the word will be a food parcel dropped among refugees. At other times it will seem a luxury, possibly a decadence. The word, to be read by male and female, young and old, to be read as high culture or original sin will have to stare back at every pair of eyes set upon it, will not wear thin through too much use. The word, every word, will have to hold its own in the sentence, in the paragraph, in the chapter, in the book, on the bookshelf, in the library, as chanted, as whispered, as defamed, as ignored, as seized, as libelled, as sung into a hymn of praise. All this the word, every word, must withstand and escape, to tell its story, now multiple, now threadbare, wheresoever it falls. The choosing of the word is something like the arming of a knight and if it seems ritualistic, obsessive, absurd, then remember that its perils and its obligations are sacred; that is, consecrated, devoted and set-apart. The language of literature is not the language of the everyday. Human beings have made it Other. One of the jobs of the writer now is to go on respecting it as Other.

Whether or not my vision of art is correct, my vision of the artist has at least the virtue of consistency. If art is what I

think it is then the artist in whatever medium finds herself
with a gift and a discipline that demands her life.

The single-mindedness of those who make rather than
fake art is interpreted as diffidence, arrogance, madness,
cruelty, remoteness, paranoia. Freud called it sublimation
and wish-fulfilment. The common theory of the artist as one
possessed is well known, but I think it truer to call the artist
one in possession; in full possession of a reality less partial
than the reality apprehended by most people. The artist
cannot occupy middle ground, and the warm nooks of
humanity are not for her, she lives on the mountainside, in
the desert, on the sea. The condition of the artist is a
condition of Remove.

I do not mean that artists live like monks, of course they
don't, and nor do I mean that artists live in shacks.
Michelangelo had five palaces and the only reason that
Mozart is buried in a pauper's grave is that he spent
everything he was given and died young. The myth of the
impoverished artist is as badly sourced as the myth of the
mad artist. A list would reveal quite a different story. The
condition of Remove is rather like the allegiance of the
knight who is glad to eat drink and be merry but listening
always for the insistent voice, the work to be done above all
things else.

I do not understand why we take marriage vows for
granted, but suspect those who know that art demands
loyalty at least as great. The passion that I feel for language is
not a passion I could feel for anything or for anyone else.
When I say that my work comes first, I mean that what that
work embodies for me is an elusive chase after perfection

over ground increasingly bogged. I suppose it is a Holy Grail and I know that I shall never find it but if I say that it is worth chasing, even if it does not exist, then I hope you will understand me. It may well be that nothing solid actually exists, but what might exist is energy, is space. And I have not discovered a more energetic space than art.

But I have said these things in *Sexing the Cherry*.

My work is rooted in silence. It grows out of deep beds of contemplation, where words, which are living things, can form and re-form into new wholes. What is visible, the finished books, are underpinned by the fertility of un-counted hours. A writer has no use for the clock. A writer lives in an infinity of days, time without end, ploughed under.

It is sometimes necessary to be silent for months before the central image of a book can occur. I do not write every day, I read every day, think every day, work in the garden every day, and recognise in nature the same slow complicity. The same inevitability. The moment will arrive, always it does, it can be predicted but it cannot be demanded. I do not think of this as inspiration. I think of it as readiness. A writer lives in a constant state of readiness. For me, the fragments of the image I seek are stellar; they beguile me, as stars do, I seek to describe them, to interpret them, but I cannot possess them, they are too far away. At last and for no straightfor-ward reason, but out of patience and searching, I find that

what was remote is in my hands. Still uncut, unworked, but present.

This gift can concentrate itself into a single line: 'Why is the measure of love loss?' from which the other lines are gradually taken, like Adam's rib, or it can concentrate itself as the returning thought of a book. In *Art & Lies*, the returning thought is this: 'The beatland of my body is not my kingdom's scope.'

Once returned, the gift, the image, must be exploded again, like mercury, throughout every part of the book. The self-consistency of a piece of work is only superficially to do with theme or story or character link. Any decent jobber can nail together a workmanlike piece of literary furniture but the true writer will display more than superior technique. The spirit of a work that is going to continue is not to be found in the itemisation of joints and finish. It is the difference between the living and the dead. A fully realised work has an identity that is not the identity of its characters or the identity of its author. A reader can fall in love with what is alive through time. Such a book is not an object it is a relationship.

The relationships within the book itself are relationships of language. Painters, musicians and mathematicians recognise that certain forms agree (even when they seem to disagree) and that it is this agreement of forms that gives us pleasure. There have been many attempts to understand painting and music according to a discoverable series of rules, and although the rules work, as they do in architecture, we do not live in a mechanistic universe, and the effort of the artist is towards how far these rules can be stretched,

altered, re-interpreted, even changed. Changes in ideas of beauty are entirely to do with the new ways of seeing that artists offer from time to time. There is the inevitable resistance (We don't paint like that, we don't write like that, etc.) and then, as lesser artists catch on, dilute, broadcast, more and more people are convinced, and what was a revolution becomes a commonplace. The round begins again but the writer, the painter, has to be indifferent to all that and to continue to seek out the lines that draw together what is apparently unrelated.

Relationships of language are not only grammatical. If they were, textbooks would rank as the finest literature in the world. What a writer is looking for are the relationships within language. The tensions and harmonies between word and meaning that gradually can be resolved into form. What moves us, what can affect us through time, are not words loosely clothing ideas but words with the full impact of meaning stamped through them.

It is redundant to try to analyse a poem, or a piece of fiction that undertakes poetic principles, by separating out the parts, meaning on one side, words on the other. When a thing is perfectly made it has no fastenings or seams. It will not come apart in your hands. What you do manage to pull to pieces is a construct of your own. A fully realised piece of work cannot be put into 'other words'. Change the words, even by trying to substitute dictionary definitions, and you will change the meaning. This is not because language is imprecise and subject to landslide, it is because it is exact. In the right hands it is exact.

What is exact? The chosen words and the relationship

among the words. Of course there are passages where the best writers still fail but we should not care about that. The effort towards exactness is the necessary effort and when writers succeed, all of us are enriched. When writers fail none suffer as much as they themselves.

Relationships among words are subtle and if the writer is to develop her ear she has to do so through the work of the past. I have to respect my ancestors and not try to part company before we know each other well. A writer uninterested in her lineage is a writer who has no lineage. The slow gestations and transformations of language are my proper study and there can be no limit on that study. I cannot do new work without known work. Major writers and minor writers alike are vital. The only criterion is that they be true; that they had something a little different to say and a way of saying it that was entirely their own. To live alongside such writers is to live within a complete literary tradition. No-one need be exiled from the privilege of language so long as those books are on public shelves. When they are on CD-Rom I wonder if a writer with a back-ground like my own will be able to get at what she needs? How will she know what she needs if she cannot steal from shelf to shelf, ignorant but curious and with an appetite for eating words?

Eating words and listening to them rumbling in the gut is how a writer learns the acid and alkali of language. It is a process at the same time physical and intellectual. The writer has to hear language until she develops perfect pitch, but she also has to feel language, to know it sweat and dry. The writer finds that words are visceral, and when she can eat

them, wear them, and enter them like tunnels she discovers that the alleged separation between word and meaning between writer and word is theoretical.

But I have said these things in *Art & Lies*.

In my own fiction I try to drive together lyric intensity and breadth of ideas. It is not possible, not desirable, I think, to maintain lyrical intensity over very long stretches and this is something every poet working with size has had to think about. It is to poets that I turn for the lessons I need and the lesson seems to be to use variety of mood and tone to make way for those intenser moments where the writer and the word are working at maximum tautness. To pay a little slack around those places makes it possible for the reader to bear them. I do not mean that any part of the work should be less than the best it needs to be, but the writer's critical judgement is in deciding where the weights and measures should be placed. There is no system for working this out in advance and there is no trick to be learned. There is only constant experiment and a very definite idea of what it is one wants to achieve. I have said before that a writer does not work in an inspirational daze but in a fully conscious compact with words. This state of fully-consciousness allows for penetration into states of super-consciousness and every true writer finds a gift of wings. To assume that the wings can be ready bought and fitted is a problem for modern Daedaluses everywhere.

Variety of tone and mood, which longer work needs, is

not got simply by displaying a selection of goods and gadgets. There is much more to be done than adding character or plot interest or philosophical digressions. The fabric of a book is more than its material; it is the weave of the words, and the lighter textures will have to show their own colour and style as obviously if not as sublimely as the richer cuts. Tennyson and Wordsworth are particularly good at this, which is why it is so terrible when they are particularly bad at it, and most readers will remember ploughing through dreadful bogs of *Maud* or *The Excursion* where there is no poetry and no relief. Dickens runs into the same kind of trouble and I think that the reason for those failures is no more arcane than this: Exhaustion.

Huge pieces of work are particularly difficult to sustain and it seems inevitable that the lighter measures within them sometimes become so light that they evaporate, or so weighed down with their author's sweat that they weigh us down with them. When I read poetry or prose of any kind from the nineteenth century what often strikes me is a sense of *toil*. I do not find it in the Romantics and their pre-decessors. The nineteenth century was a toilsome century, and no writer can escape their period, although it is interesting that Yeats and Graves, whom we think of as Modern, but who are Victorian-reared both chose the lyric form as a means of escape.

Graves argues for the lyric, choosing jewel-like intensity over breadth of ideas, a poetic philosophy shared by the Imagists but undermined by T. S. Eliot who succeeded in his search for new vigour in a poem of length. In any case, Graves, unlike the Imagist poets, has achieved in his lifetime

of lyric, an organic continuity, so that the individual poems flow together, a river of writing unstopped by dates and collections and themes. This organic continuity brings Graves, as a poet, close to George Herbert (1593–1633) whose meditative religious lyrics form a pattern outside of their pattern, so that when read together, they seem to the reader to be some great arc made up of many colours and perfectly broken into one another.

This river of writing, this rainbow of writing is not what the reader finds in say, Keats, or Marianne Moore. It is peculiar to those writers who were obsessed by a single all-consuming idea; in Herbert's case, God, and for Graves, the goddess as lover and Muse.

It is perhaps unsurprising that I should be in sympathy with poets of obsession, and in particular with those two very different poets of religious and romantic ecstasy. As a reader I am drawn to them, but it is as a writer that I owe them the greater debt.

I want for my own work those talismans of intensity that I find in their work, and if I look to more expansive writers for breadth, I look to Herbert and to Graves for perfect expressions of taut emotion.

When a writer has learned how to use rhythm and pace and accent and design to move her matter along she is still left with the question of poetry and it is not a question she can ignore if she hopes to do more than tell a story.

If prose-fiction is to survive it will have to do more than to tell a story. Fiction that is printed television is redundant

fiction. Fiction that is a modern copy of a nineteenth-century novel is no better than any other kind of reproduction furniture. What literature can offer, it should be unembarrassed about offering, there is no need for art to strive to be like everything else. In so much as television and film have largely occupied the narrative function of the novel, just as the novel annexed the narrative function of epic poetry, fiction will have to move on, and find new territory of its own.

We have to admit that with one or two surprising exceptions, fiction is not being developed by writers who understand the nature of the problem. This is partly because too many academics, critics and reviewers tout a system in which Modernism is a kind of cul-de-sac, a literary bywater which produced a few brilliant names but which was errant to the true current of literature, deemed to flow, fiction-wise, from George Eliot to Anita Brookner. Writers who we are applauding and encouraging are not writers who are doing new work. They are writers who are plodding on with methods and forms worked out by their ancestors. And not their Modernist ancestors.

To assume that Modernism has no real relevance to the way that we need to be developing fiction now, is to condemn writers and readers to a dingy Victorian twilight. To say that the experimental novel is dead is to say that literature is dead. Literature is experimental. Once the novel was *novel*; if we cannot continue to alter it, to expand its boundaries without dropping it into even greater formlessness than the shape tempts, then we can only museum it. Literature is not a museum it is a living thing.

Modernism has happened and it was the mainstream. It is no use looking for the new George Eliot, and if she were to appear, what a ghastly creature she would be. We cannot look for the new Virginia Woolf either. We can only look for writers who know what tradition is, who understand Modernism within that tradition, and who are committed to a fresh development of language and to new forms of writing.

There is something else besides the problem of lineage.

It is the problem of language. I know that it should be the most obvious thing in the world to say that what a writer can offer, uniquely, is language. What should distinguish a writer who chooses the printed page rather than the moving screen, is language. What distinguishes one printed page from another, is language. I do not mean meaning.

When we look backwards into literature and look at the texts themselves, not adaptations of texts nor our memory of them, what we notice is that those writers who still compel us and who cross time as if it were a room, are those writers marked out by their compact with words. Why is Dickens a great writer and Trollope hardly a writer at all? I ask you to open at random any work by either man and to compare. Ignore the subject matter, compare the words and the relationships among the words. I do not want to upset any Trollope fans but I do not think I shall, because the word 'Trollope' and the word 'fanatic' are as united as the word

'beef' and the word 'vegetarian'. I do know that people who do not actually read books always claim to be great admirers of Trollope.

What is the matter with Trollope? Too much matter is the matter. The accumulation of detail for its own sake. The overflowing contents drawer of the quintessential Victorian novel. (Look at Dickens again and see how little detail there is; the man proceeds by leaps not lists.) Trollope does not love language, he uses it as a vehicle for story-telling, he does not understand the energy of words. He does not understand art as energetic space.

If I say that now, writing now, are too many people who have no concept of art as energy, of art as space, I think you will follow me. I think you will realise that if fiction is to have any future in the technological dream/nightmare of the twenty-first century, it needs, more than ever, to remember itself as imaginative, innovative, Other. To do this the writer must reclaim lineage and language.

Which brings me to questions of style.

When a new writer appears on the scene we should not expect miracles (they come later), we should expect a high degree of technical ability and a distinctive note which has nothing to do with subject matter. Such are the beginnings of an individual style. Whether or not there is any development is largely up to the writer and although we can blame lack of discipline and lack of encouragement for the wastelands of talent, perhaps we forget

that without integrity a writer cannot develop at all.

Integrity is the true writer's determination not to buckle under market forces, nor to strangle her own voice for the sake of a public who prefers its words in whispers. The pressures on young writers to produce to order and to produce more of the same, if they have had a success, is now at overload, and the media act viciously in either ignoring or pillorying any voice that is not their kind of journalese. A writer needs to be unswayed by praise or blame and sceptical of the easy friendships and sudden enmities offered by the industry in which she now has to work. The commercialisation of art has inevitably included the commercialisation of the writer, who is now expected to be a public figure and a target (no other word will do) of interest. The writer should refuse all definitions; of herself, and of her work, and remember that whether her work sells or whether it doesn't, whether it is loved or it is not, it is the same piece of work. Reaction cannot alter what is written. And what is written is the writer's true home.

This determination to live by the work and be known by the work is not popular but it is a writer's humility and the only humility helpful to her. Simply, the work is more important than she is, and to put it first, to put it above everything, is to allow nothing to compromise it. That includes the ordinary desire to be liked.

If a writer needs integrity, she also needs discipline. The gift of a vision and a voice is a more difficult gift than magic beans that grow into magic beanstalks. If a writer is to

succeed on her own terms she will have to take the daytime and the night-time to make a chisel of her style.

The chisel must be capable of shaping any material however unlikely. It has to leave runnels of great strength and infinite delicacy. In her own hands, the chisel will come to feel light and assured, as she fines it to take her grip and no other. If someone borrows it, it will handle like a clumsy tool or perform like a trick. And yet to her, as she works with it and works upon it, it will become the most precise instrument she knows. There are plenty of tools a writer can beg or borrow, but her chisel she must make for herself, just as Michelangelo did.

A writer's style is distinctive, of course it is, or is it?

It should be obvious from a single page who it is we are reading but very often it is not. The fashion for styleless prose is something to do with trying to get away from the artificial. What could be more artificial than the individual who sounds just like everybody else?

A writer's style is all she has and the price of the making of it is everything she has. To fit language to her hand she must command at her hand resources of body and mind, totality of self and the self of her that acts as a skein to carry the world in. She must be well read, she must be clever. She must be curious, she must be sharp. Whatever she can muster to her fingertips, let her, and her hands will begin to control the instrument she desires.

A writer's style has in it many voices, many connections.

She will have learned how her dead friends write before she has learned how she herself writes. And as she pushes a little further than she could she comes to admire those dead writers more and more. It is a perpetual dialogue, between the one who has written, the one who is writing. Chisel as baton passed from hand to hand, each time re-turned.

When we read a modern writer who is true, part of the excitement we get from her style is the excitement of other styles that have passed that way. This is not style as collage, it is style as polyphony, where the past is audible again. I know that when I read Virginia Woolf, I like to go back to Marvell. Why? Rigorous pursuit of the image. The same witty determination to get it exact and surprisingly so. When I read Adrienne Rich I want to look again at Browning.

I am not suggesting that Adrienne Rich would consciously choose Browning as one of her private ancestors and it really doesn't matter whether she would or not. The alert reader, especially the reader/writer, is ready for clues, clues that unravel the past, as well as the modern writer we are enjoying. The chase to the bookshelf, to test this theory, that idea, is a hunt we can expect from writers who bring multitudes with them.

For myself, as a practitioner, I still take instruction and pleasure from sincere parody. Only strong styles can be parodied, but the skill of the writer as mimic is a useful one in the development of a personal style. Everybody knows Henry Reed's parody of T. S. Eliot ('Chard Whitlow'), and some readers might be familiar with the fate of Tennyson's 'The Ballad of Oriana'. That is not a true parody, for the only device is to substitute the refrain word 'Oriana' with

'Bottoms up'. Poor Tennyson. But it does rather serve him right. And we all make the same ponderous parodies of ourselves from time to time, no writer altogether escapes, and it is an exercise in good humour as well as real worth, to parody oneself consciously. Providing of course that the results are then burned.

A writer should know how to copy. I think that only by knowing how to copy can one avoid copying. It is sometimes very easy to slip into the style of another writer, and occasionally this solves a problem, in which case, borrow and be damned. But know what it is and why.

Problems of self-parody are a result of hardening a style into a formula. When a writer has made her chisel and learned how to use it, it is tempting to go on using it in a way that was once exhilarating but which has become comfortable. To continue to do new work is to continue a development of style that allows the writer to surprise herself. The distinctive notes, the authority and the poetry should always be present but they should not be present in an increasingly familiar package. We all know of writers who just keep writing the same book, but what is sadder is when a true writer seems to run out of books. T. S. Eliot observed that to continue to develop stylistically, a writer had to continue to develop emotionally. This is a surprisingly feminine thing to say but when we apply it to the work of past writers whom we admire, it begins to seem like a very sound observation. If, as I have claimed, a writer's style is honed out of everything she is, then, that everything could get used up. It is a commonplace of psychology that human

beings, beyond a certain age, find it difficult to supplement their personalities with new emotional understandings. If this happens to the writer, she is lost. It may not be *what* she has to say, it may be that she has no convincing way of saying it. Style is conviction even at its most ambiguous.

It is clear that Eliot's own long-poem stylistic development, the journey from *The Waste Land* to *Four Quartets*, is an emotional development of a profound order. I do not find Eliot's Catholicism reactionary, or rather, I don't care whether or not it was reactionary, his conversion detonated out of him new charges of feeling. To express this late fire Eliot re-fired his style. W. H. Auden did not undertake such furnace work.

I do not want the reader to imagine that there is any conflict between obsession and movement. The obsessive writer is not a psychopath incapable of letting in any reality other than his own. A writer's obsession is her beguilement, the love-affair without which . . .

Robert Graves wrote some of his best poems in the last five years of his life, and while they are unmistakably Graves, they are also new fathomed and deep-found. It is no more likely that obsession will freeze a writer into habits than lack of it. It is that a writer cannot afford to form habits, and if to prevent that, she invents for herself rules as arbitrary as those of convent or monastery, she will know that the purpose is to keep her awake when she is most in danger of sleeping.

A wide awake writer breathes more deeply than one who is going to sleep. The breath of a writer is everywhere in what she writes. It is the breath of a writer that determines the cadences of the lines, the particular sound to the inner ear, that judges true or false.

To know that her style is still alive the writer needs the test of her own breath. She can go against the rhythm, break it up, alter the stress, but she must know what her own beats are and how to shape them together as singers do. So often, bad prose, bad poetry, is lungless poetry and prose with no air in it. Good writing is not silent, it reads itself aloud, dictating pace, pausing places, passing places, sudden speed. If a line is ugly or wrong it is usually stressed wrong, which includes having chosen wrong words. This is an insensitivity to sound which is apparent when the line is read out loud.

The breath of a writer is not her conversational tone, it is more profound than that. Just as a painter has a particular turn of fingers and wrist that belongs to his sense of his body, so a writer breathes to her own pulse and that should be evident throughout her work.

When T. S. Eliot talked about 'impersonality' in his famous essay 'Tradition and Individual Talent' (1919) he did not intend that his cry against autobiography would be used as a theory of aridity. Eliot is an emotional poet and the poets he particularly loved, the Metaphysicals and Dante, are poets of feeling but tightly kept.

Eliot was an enemy of sentimentality and easy solutions,

and everybody remembers that in his essay 'The Metaphysical Poets' (1921) he said that 'poets in our civilisation, as it exists at present, must be difficult'. He did not mean that poets should be sterile or wilfully obscure. It is clear from the essay that his admiration for the Metaphysicals is admiration of a sensibility that could absorb awkward 'unpoetic' material and render it through fresh images into emotional experience. To do that demands a concentration *away* from Self, an impersonality that allows other realities to find a voice that is more than reported speech. And it means that the poet's preoccupations do not necessarily become the preoccupations of the poem. The space that art creates is space outside of a relentless self, a meditation that gives both release and energy.

Why does this assume difficulty? The English language has been in use for a very long time and a vast amount of poetry and drama and stories and fiction have been written in it already. These vast amounts have played a significant role in the development of the language they use and which their followers must use. It is impossible to find fresh images, fresh ways of transmitting emotional experience, without fresh use of language. How are we to do that without deliberately avoiding the obvious? This can seem like wilful obscurity and sometimes it is, and sometimes the writer gets it wrong, but we have to trust our writers and to recognise that the 'difficulty' of new work is often nothing more than our difficulty with the unfamiliar.

A writer has to get away from cliché and can never never call a spade a spade. To bring back to us starts of feeling that can volt through the thickness of the day means direct

injections of language, undiluted, unmediated. Language that sounds as though it is being made, made now, and not out of the banality of television speak, that ubiquitous Esperanto, but out of stubborn desire to express exactly that which resists expression and exactitude.

A writer's pulse, the beat passing through the work that makes the work her own, is the only signature she needs. Shakespeare is the best example of a writer about whom we know almost nothing and yet whose voice is so distinctive that if we met him on the street we are sure we should recognise him at once. Shakespeare's impersonality is not lack of personality in fact, the everywhereness of Shakespeare in his plays has encouraged endless attempts to reconstruct the man. But what can we say about him? That he is a Royalist and that he is not. That he believes in Order and that he does not. That he despises women and that he venerates them. That he is an advocate of excess and lectures against it. That he believes that some murders are justifiable but that no murderer is. Like The Bible, the Works of Shakespeare can be used to prove anything. Like the massive central presence of Godhead in The Bible, the central presence of Shakespeare is all pervasive, but what is it? As we confidently come to talk about the solid presence that meets us at every performance, at every reading, we find we cannot talk about it at all.

To perform the Indian Rope Trick is what Eliot meant by Impersonality.

How does the writer do this? Through development of style.

Style; sensibility and technique distinctively brought together, frees the writer from the weight of her own personality, gives to her an incandescence of personality, so that what she can express is more than, other than, what she is. Through the development of style imagination is allowed full play. The writer is not restricted to what she has experienced or to what she knows, she is let loose outside of her own dimensions. This is why art can speak to so many different kinds of people regardless of time and place. It is why it is so foolish to try and reconstruct the writer from the work.

It is style that makes a nonsense of conventional boundaries between fiction and fact. Style that refuses history as documentary and recognises that history is as much in the reconstruction as in the moment. It is tempting to wonder whether the Roman Empire existed simply so that Gibbon could write about it. Style is not reverential or dependent on past authority even though it always respects its private ancestors. A personal style is not a kind of literary jet-pack that powers its owner beyond the boredom of ordinary sentences, it is a primary world to which every-thing is subordinated, including the writer. I realise that I am coming close to Yeats and his planchette, but really, Yeats and his planchette has no quarrel with Eliot and his impersonality theory. Writers try and get at a metaphor which best explains to themselves the strange paradoxes they experience through the act of writing which is at once the most intimate of gestures and that which seems remote, attendant, Other.

My own metaphor is that of the Indian Rope Trick,

perhaps because in the East it would not seem so odd to say that the total realisation of Self necessary for the artist and evinced in her style is that which makes possible a total escape from Self. I know that ideas about the Self can only be approximate but it might be fair to say that the artist is less approximate than other people.

But I have said these things in *Oranges are not the only fruit*.

To bring the present up close, and nothing is further away from us than an understanding of our own time, the fiction writer will choose a device. The device, unlike the language, is only a means to an end, for instance, it is unimportant to play Shakespeare according to period. I have twice used the device of history, not because I am interested in Costume Drama Realism, or Magic Realism or any other Realism but because I wanted to create an imaginative reality sufficiently at odds with our daily reality to startle us out of it. I had achieved this with *Oranges* and I wanted to broaden my experiment.

Whilst I do not think that art is in competition with anything, including other works of art, I do think that media moronicness makes it impossible for the writer to assume that the reader will be ready to give literature the attention it needs. A poem, a piece of fiction of any value is not instantly accessible. The reader, like the writer, has to work, and as long as work remains a four letter word, the average reader will not understand why they should struggle through their leisure time. Will it be a struggle? It might be. What we

cannot do is judge a book by how little bother it gives us. Books can be bothersome, precisely because they are not light entertainment, and the temptation for the curious but unseasoned reader, is to switch channels. This is what satellite TV depends on. It is what kills books. The writer has to be aware of the problem, and whilst the solution is not to write printed television, one answer is to set a trap for the reader's attention. To catch it with something that glitters: the lure of a good story. I pack my pages with shiny things even though I am a writer who does not use plot as an engine or a foundation. What I do use are stories within stories within stories within stories. I am not particularly interested in folk tales or fairy tales, but I do have them about my person, and like Autolycus (*The Winter's Tale*), I find that they are assumed to be worth more than they are. As a pedlar, I know how to get a crowd round when I un-pack my bag, and if one person buys The Dog Woman, and another, a pair of webbed feet, and another, a talking orange called Jeanette, and you, a forest of red roses on a salt-rock, then I am glad of my wares, or should I call them my bewares?

Beware of writers bearing gifts. Might we be back at the Trojan horse?

I'm telling you stories. Trust me.

But I have said these things in *The Passion*.

What have I said in *Written on the Body*?

That it is possible to have done with the bricks and mortar of conventional narrative, not as monkey-business or magic, but by building a structure that is bonded by language.

Anyone who reads epic poetry knows to skip those plain embarrassing stanzas where mundane material necessary to the story has to be conveyed in verse. This mismatch is either comic or irritating, depending on your mood, but it is an inherent weakness of the high style. Classic examples can be found in *Aurora Leigh* (Elizabeth Barrett Browning) *Don Juan* (Byron) *The Rape of the Lock* (Pope). We feel that poetry should do more than tell us that somebody is waiting in the hall. It should, and of course prose handles mundane matter so much more graciously than poetry can. The pleasure got in reading a long long poem *for* the story, was easily improved upon by reading one of those exciting new novels.

Must poetry be on one side and prose on the other? Not historically, not necessarily, although we might have to go back to the Renaissance for our clues. Part of the interest in the Renaissance for leading Modernists (Woolf, Eliot, Sitwell), was an interest in their flexibility of form. It is difficult for us, who are so obsessed with labels, genres and definitions (a marked Medieval trait), to imagine a common mind that was not. The move into the Renaissance period from the medieval was a profound freeing up of ideas and interplay of ideas. The buoyancy and exuberance of the Renaissance comes out of a confidence and a curiosity that we don't have. We are insecure and cynical and this makes us hostile to experiment. The Renaissance was Experiment, and I believe that had it not been for the

disastrous effect on European culture of two World Wars, what we call Modernism might have proved only the start of a period in history as genuinely new.

I do not know. What I do know is that it is desirable now to break down the assumed barriers between poetry and prose, to let the writer use poetry when she needs intensity and prose when she does not.

What else does Shakespeare do in his plays?

What I am seeking to do in my work is to make a form that answers to twenty-first-century needs. A form that is not 'a poem' as we usually understand the term, and not 'a novel' as the term is defined by its own genesis. I do not write novels. The novel form is finished. That does not mean we should give up reading nineteenth-century novels, we should read them avidly and often. What we must do is give up writing them.

For an experimenter these are hard times. The best of times and the worst of times. The challenge is exhilarating and enviable. The struggle is vertical. Of the media, nothing needs to be said but we might ask quite what it is they are mediating except themselves? Of the critical establishment, whose job it is to make a clearing in the woods where writer and reader can meet on level ground, we might be forgiven for noticing that they plant more obstacles than they remove. Academics, who are sometimes critics, and often reviewers, are notorious fence-sitters, afraid of ridicule, afraid of risk, the risk and ridicule that the true writer faces every time she publishes. Unlike writers, academics draw a

salary and this will not be taken away from them if they back a wild horse. They do not back wild horses; they record the virtues of nags long past their prime.

The true writer will have to build up her readership from among those who still want to read and who want more than the glories of the past nicely reproduced. I have been able to build a readership, largely through a young, student population, who want my books on their courses and by their beds. Reading is sexy.

They know it is. They know that there is such a thing as art and that it is not interchangeable with the word 'entertainment'. They do not care for maundering middle-class middle-aged elegies. Judge the work not the writer seems to be what a new generation is prepared to do. It is for a new generation that I write.

A NOTE ON THE TYPE

The text of this book was set in Bembo, a
facsimile of a typeface cut by Francesco Griffo
for Aldus Manutius, the celebrated Venetian
printer, in 1495. The face was named for Pietro
Cardinal Bembo, the author of the small treatise
entitled *De Ætna* in which it first appeared.
Through the research of Stanley Morison, it is
now generally acknowledged that all oldstyle
type designs up to the time of William Caslon
can be traced to the Bembo cut.

The present-day version of Bembo was in-
troduced by the Monotype Corporation of Lon-
don in 1929. Sturdy, well balanced, and finely
proportioned, Bembo is a face of rare beauty and
great legibility in all of its sizes.

Composed in Great Britain